RUSSIA

EUROPE

Atlantic Ocean

Mediterranean Sea

INDIA

AFRICA

SOUTH AMERICA

# ADVENTURE
## GUIDE
# HOTEL STORIES

Peter McGinn

© 2005 Assouline Publishing
601 West 26th Street, 18th floor
New York, NY 10001, USA
Tel.: 212 989-6810   Fax: 212 647-0005
www.assouline.com

ISBN: 2 84323 667 3

Color separation: Gravor (Switzerland)
Printed by Grafiche Milani (Italy).

Translated from the French by Diana Stewart.

FRANCISCA MATTÉOLI

# ADVENTURE
## ——— GUIDE ———
# HOTEL STORIES

ASSOULINE

*My first adventure? That of a young girl who left Chile to come to France.*
*A journey that took over three weeks from Graneros to Paris,*
*with my grandparents, my parents and my sister, by car, train, boat,*
*and then again by car. First of all we took a train to cross the Andes Cordillera.*
*Upon arrival in Christ of the Andes at some 11,500 feet of altitude,*
*between Chile and Argentina, we changed trains and took the Transandin*
*that took us to Portillo and then to Buenos Aires. There we waited for Le Pasteur,*
*one of the last flagships of the famous Messageries Maritimes to make this voyage*
*from Buenos Aires. In the morning, passengers were served broth on the deck,*
*because we were going from hot to cold. The grown-ups met in the bar.*
*Crossing the equator, that mythical imaginary line, was suitably celebrated of*
*course, by "Poseidon's arrival," and by all kinds of festivities. A succession of halts.*
*Montevideo, Santos in Brazil, Rio, Dakar, the Canary Islands, Lisbon.*
*Finally, we arrived in France, at Le Havre, in the fog. We took two cars.*
*After a month traveling the world, yet more travel. My grandparents took*
*the first car. We were in the second car. Our trunks followed by train.*
*We did not know what to expect, we had no idea of what our lives*
*were going to be like. I did not even know the word "Bonjour" in French,*
*but I already knew what an adventure was.*

*Francisca Mattéoli*

# CONTENTS

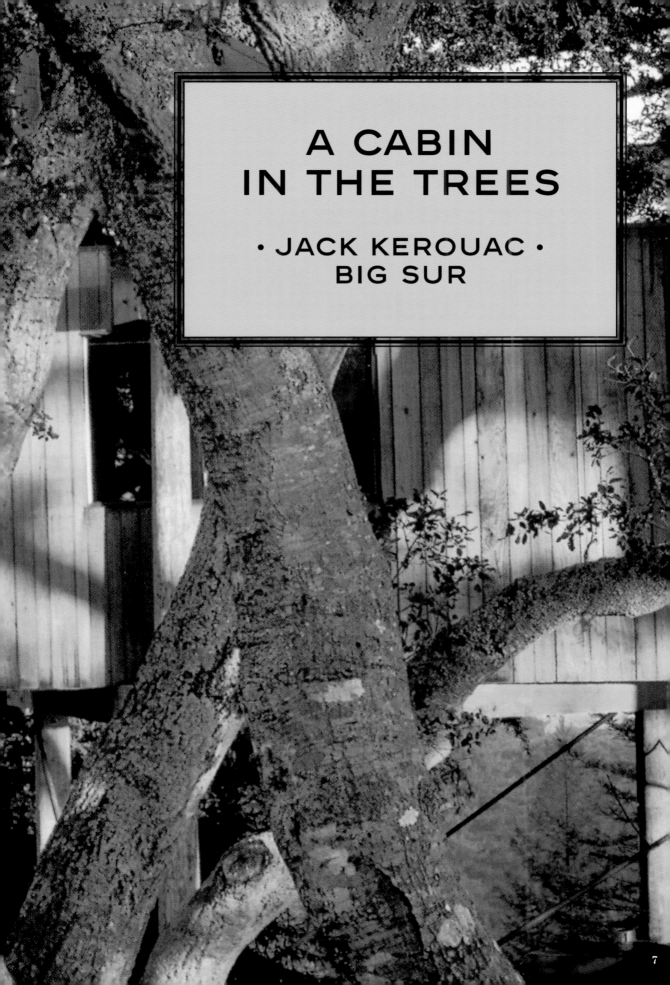

# A CABIN IN THE TREES

## · JACK KEROUAC ·
BIG SUR

Summer 1960. Jack Kerouac arrived in Big Sur, the hide-away for hermits south of San Francisco, with the firm intention of forgetting everything. He could no longer tolerate being forced to conform with his image, that of a fighter who had gone "off his rocker," as depicted in *On the Road*. He had had enough of being hunted by the media, fans, inquisitive bystanders, and cadgers, forced to play his part as the King of the Beat Generation like an obedient puppet. Kerouac's success was the worst thing that could have happened to him. Depressed and embittered by years of rejection (the book he wrote in 1948 was only published in 1957), he spent his time drinking, trying to forget he had become everything he hated. Kerouac continued to publish books, but they were mainly works written before he became famous, works that nobody wanted. He appeared on television but often had to cancel inter-views because of the state he was in. And even when he agreed to be on television, journalists found him arro-gant and incoherent. Kerouac's friend, the poet Lawrence Ferlinghetti, had rented a cabin in Bixby Canyon and advised him to go to Big Sur on the Pacific coast, a place akin to a village, situated between Malpaso Creek and the Salinas valley, right out in the

wilderness. Big Sur, with its rocky creeks, its forests of sequoias twisted by the wind, and its cabins—sus-pended from the cliffs—scattered all around, had seduced bohemians and artists enamored with wild countryside and freedom. This stay did not give Kerouac any of the peace he had expected. On the contrary. He soon detested the place, and his mental condition only got worse. He was terrified by the countryside and by the noises coming from the surrounding forest. Once he thought he saw flying saucers. Another time, angels. Kerouac often woke up in the middle of the night groaning, and a bottle was never far away. One night he

*The king of the Beat Generation who just wanted to disappear...*

*ack Kerouac, Villa Muneria garden wall, Tanger — he'd preceded me & Peter O. in Yugoslav freighter by a month to help type Burroughs' Interzone "word-hoard" manuscript assembled for Naked Lunch. Jack left for Paris a week and a half later, On The Road published earlier that year — he'd already written twelve books, Visions, Dreams, Blues, in the "Legend of Duluoz" series, up to Desolation Angels Part I, late 1957.*

*Allen Ginsberg*

was taken with delirium tremens, and his hands shook so much that he could not even manage to light a cigarette. During the day, he panicked for no reason at all, refused to meet Henry Miller, who lived nearby, and only just about managed to drag himself to Nepenthe, a restaurant on Highway 1, to down one Manhattan after another. A new novel was born from this adventure on the edge of insanity: *Big Sur*.

The tale of an ultimate quest, saturated with alcohol and Benzedrine. An appeal as desperate and wild as the previous ones, bursting forth from a cabin in the middle of nowhere, amongst the ferns on the moor. The King of the Beat Generation ended his book with a poem dedicated to the pestering "voices" of the Pacific Ocean. Without having found peace there.

Big Sur is not a destination for weak or tenderhearted people attracted by the soft pastoral countryside. Big Sur is fantastic, extreme, heartrending, fascinating, bizarre, and insane. Those who appreciate it like strange places, solitude, stimulating air, an utterly and totally conserved countryside, and worlds that are quite apart. They love novels by Steinbeck, who lived in nearby Monterey.

From the Post Ranch Inn you can see everything that contributes to the beauty of this site. Perched high, isolated, the hotel—if one can call it that, with its astonishing houses in the forest—dominates the surrounding ocean and mountains. It is the perfect place for a honeymoon. The dream of freedom that Kerouac had hoped for, it is also a superb enclave of luxurious wilderness (with giant trees and wooded hills) made

from simple and beautiful things: wood, glass, and stone. Just nearby are the Carmel beaches, the ever so famous 17-Mile Drive, and the Point Lobos nature reserve (another miraculously unscathed sanctuary where one can see condors, otters, and seals "barking" from their boulders). And upon following the attractively indicated footpaths, one wonders, amazed, how such a place has managed to remain so unspoiled—without any unsightly signposts, or anything else to mar the view.

The Post Ranch Inn dates from 1867, a time when pioneers such as William Brainard Post landed in California with their heads full of dreams. Little by little, the Post family has turned a cattle ranch into a magnificent hotel, with bedrooms in the middle of the woods, private villas set apart from the hotel, and cabins perched in the majestic trees. Its surprising architecture gives you the impression that the hotel has just sprung from the forest. This is undoubtedly where that feeling of a complete change of scenery, that sensation of being truly free, comes from. Kerouac may not have tamed his demons, but in this unique location, it is easy to understand why Big Sur and its area have remained a mythical bower for artists, intellectuals, eccentrics, and rebels, whether famous or not.

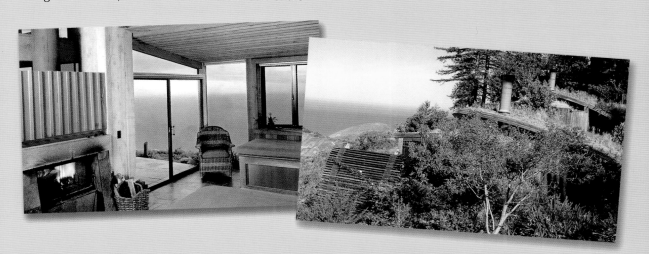

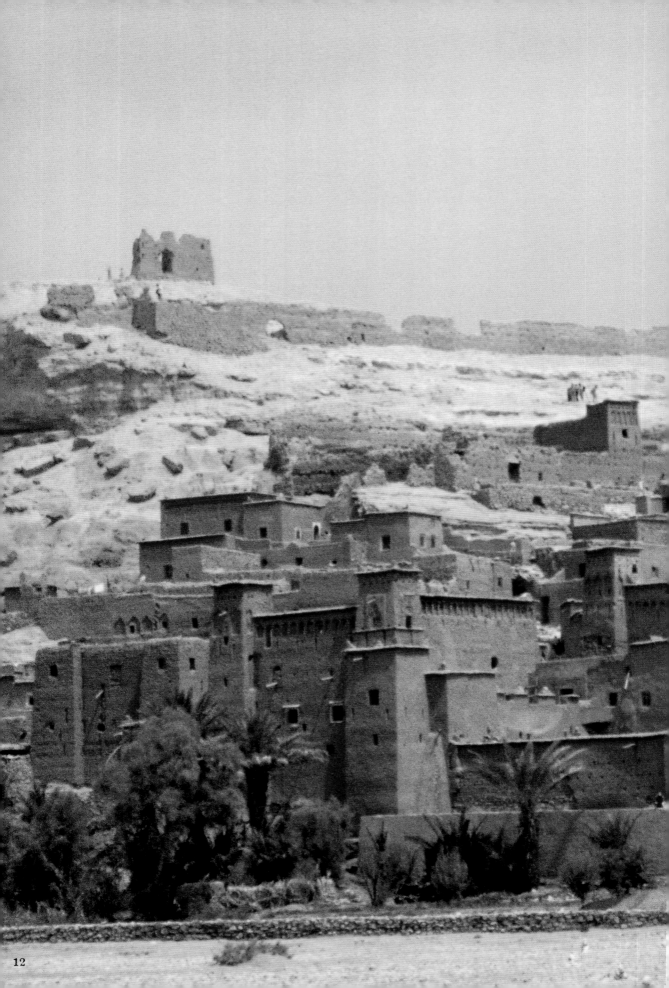

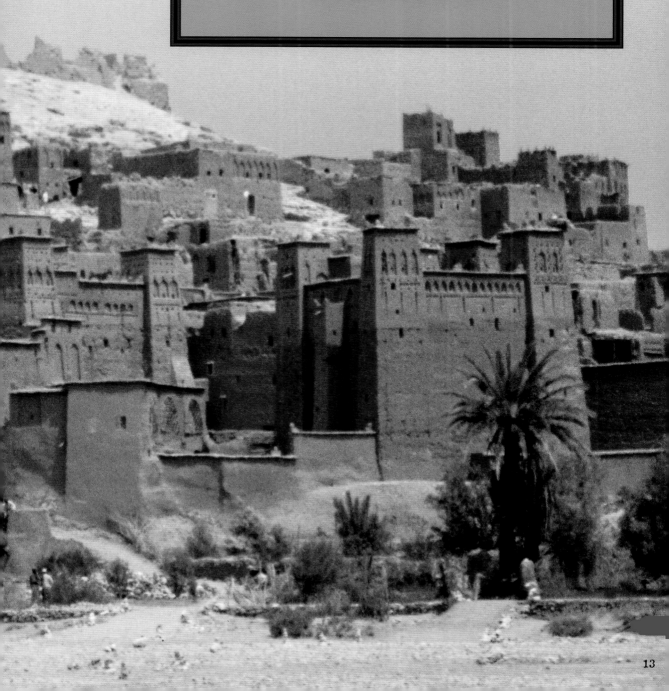

# A KASBAH BY THE DUNES

## • THE MAN WHO WOULD BE KING •
### MORROCO

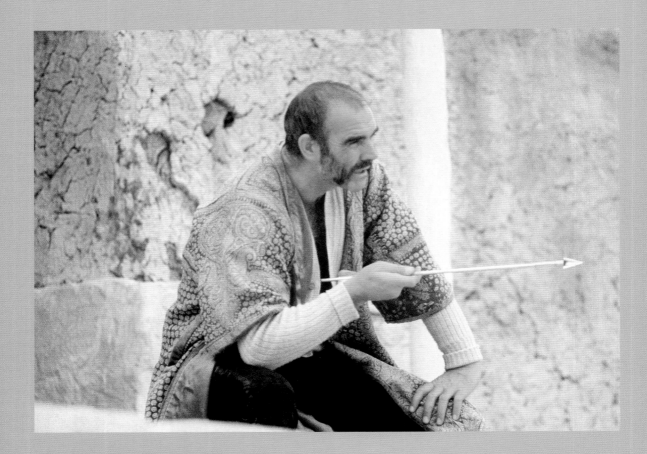

Writer, painter, elephant hunter, actor, director, boxing champion, officer in the Mexican cavalry, wartime correspondent, gambler, drinker, notorious seducer, and brilliant Hollywood outlaw, John Huston was meant to film this fabulous story. In fact, since the 1940s he had been thinking about a movie with, in the leading roles, Clark Gable and Humphrey Bogart (his old friend since the days of *The Treasure of the Sierra Madre*). However, Bogie's death had postponed the project. He then considered Richard Burton and Peter O'Toole, and then Robert Redford and Paul Newman—who replied with certainty that no one would ever think he was British. The movie was finally shot in 1975 with Sean Connery and Michael Caine. A dazzling duo, inimitably funny, talented, and audacious. The story? At the end of the nineteenth century, two former British soldiers, crafty and resourceful, set off to establish a kingdom—and to swindle anyone they could—in a place where no European person has ever set foot: Afghanistan. Luck is with them beyond all their hopes until, during a battle with the locals, one of them is hit by an arrow that is stopped by his cartridge belt. He is immediately declared a king, Alexander's son, and immortal.

A stroke of luck that gives cause to the accomplices for much rejoicing, as they prepare to make as much profit as possible from the situation. Unfortunately, fate tragically catches up with them.

Huston changed Kipling's novel slightly, and gave us one of the most beautiful adventure movies ever filmed. For practical reasons, he shot the film in Morocco, at the edge of the desert, in the Atlas Mountains. Dunes and sand gave birth to the most extraordinary Afghanistan you could ever imagine or dream of. A majestic and unforgettable sight that went way beyond everything that had been done before by its inventiveness, intelligence, and refinement. The brilliant Alexandre Trauner—the magician

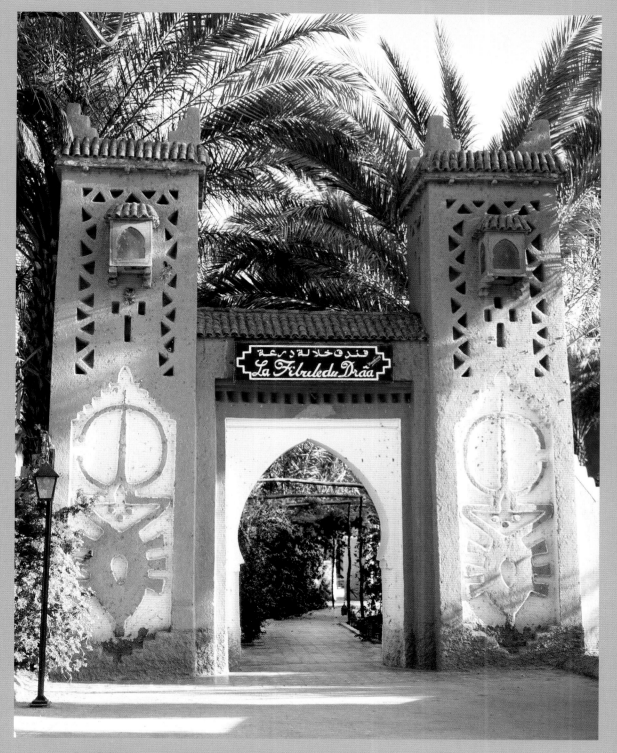

*La Fibule du Draa, an unexpected halt at the gateway to the desert.*

of *Children of Paradise*, *Irma La Douce*, and *The Apartment*—is the one who blended Morocco with incredible sets. A huge task, which took a whole year in all, including the finding of a location, the shooting, and building villages and temples. "The Greeks did not build their temples at random," Trauner said.

"They were situated in magical places, well lit by the sun, and had to provide an interesting view both when looking toward the temple and when looking out from the inside. This was the reason why they stood out in the scenery. The builders also had to be careful of the topography." The result of such a study,

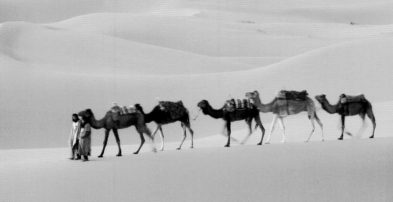

which was as expert as it was meticulous: the most fascinating encounter between a country and a story. Morocco, the Sahara, the majestic Berber fortresses, those dwelling places of the Lords of the Atlas, which, in an instant, can be drowned by furious golden winds. The region of Tifoultoute, the Draa Valley, the road from Ouarzazate to Zagora... Initially austere, stuffy in the heat, interminably long with its sand dunes and tracks that are imperceptible to tourists, the valley is suddenly transformed into a miracle, with fabulous palm tree groves, as green as a mirage, bright pink laurels, pomegranate trees, fig trees, and kasbahs—magical hotels with cool patios, protected by beautiful, almost invisible doors. The charming *Fibule du Draa* is one of these small secret jewels. An old Berber house that has become a hotel, hidden

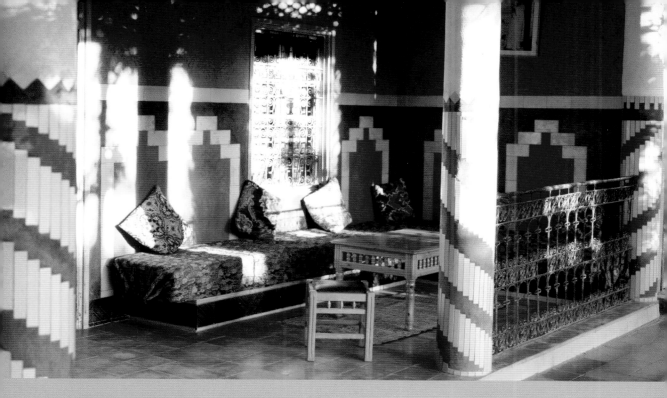

amongst the palm trees and the perfumed roses. "After the boiling hot sun, such coolness is unexpected, as are the music of the birds, the gay colors, the bowers full of flowers, and the turquoise swimming pool," said one subjugated visitor. You feel at home there, without pretension, calm and happy to have discovered this amazing place away from the heat of the blazing sun. At dawn, the really keen ones go off to tackle the desert in their four-wheel drives, on camelback, or on foot as one did in the time of the great Sahara treks... Softly sloping blond dunes, black crevices, red rocks, a strange silence, a searing light that changes color continuously, dry trees, brown brick villages that look abandoned, Berber tents that appear to have just sprung up out of the earth, peaceful groups of camels, and nonchalant nomads walking along with their troops... Sights by the dozen that visitors later attempt to describe on their return, sitting on the patio with mint tea, *mezzees,* and cinnamon-flavored oranges served under a Berber tent, in the shade of the large palm trees.

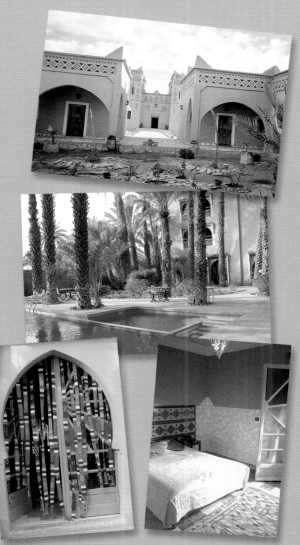

# ON HORSEBACK LIKE HERDSMEN

## • VINCENT VAN GOGH •
### CAMARGUE

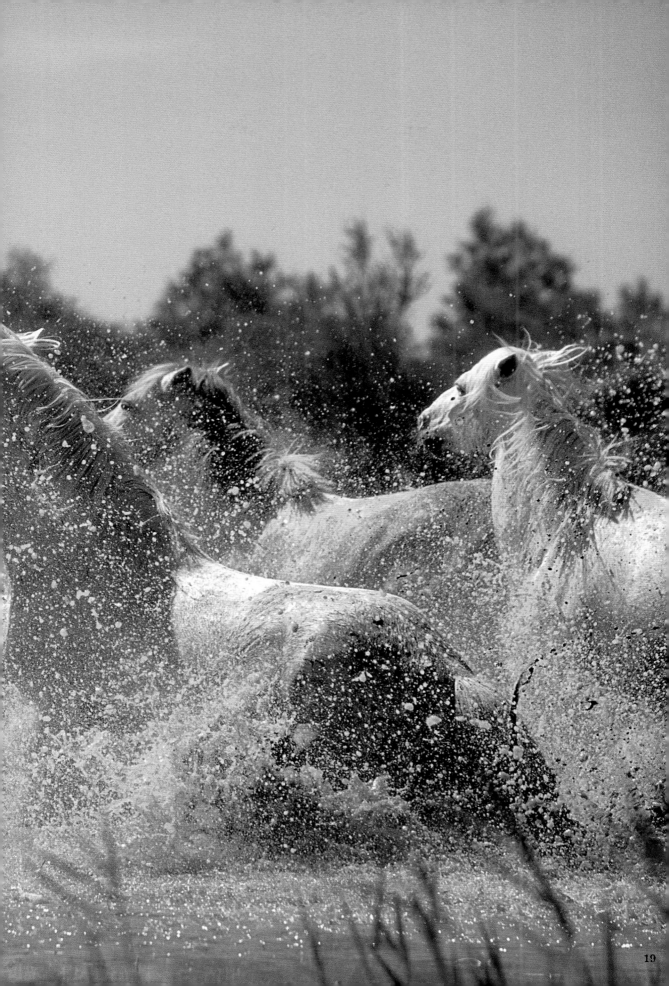

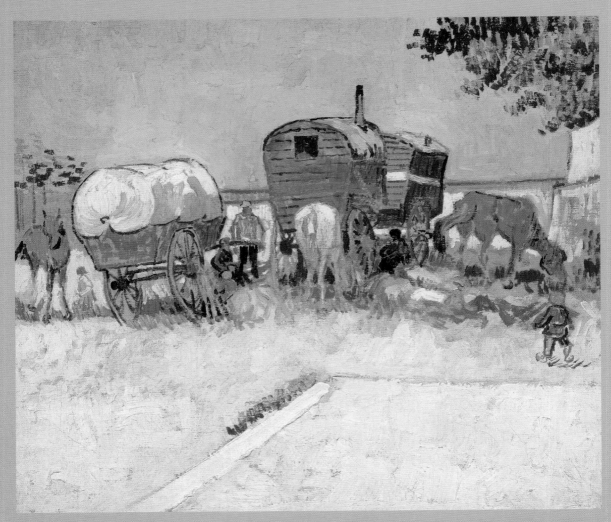

Le Pont des Bannes, on the Arles road, tells you about the real Camargue. The bedrooms are authentic herdsmen's cabins, all white, with roofs covered in reeds. Each of them has a small wooden bridge in the heart of the marsh, and all around...you can see wild nature: all that is at the heart of the herdsman's world.

It was initially a meeting place for hunters. The ranger's wife prepared the game. Little by little, the shelter became a hotel, L'Hôtel du Pont des Bannes. Once upon a time, a portal straddled a little canal, allowing the cattle to pass from one marsh to another. While passing, a bull broke a horn, a "banne" in the provincial dialect. This is where the name comes from.

Like the hotel, the region is not an ordinary one. It attracts strong personalities: the independent and the determined, who want to be free, just like their horses. An area where Arles and Saintes-Maries de la Mer are located. A land of gypsies and bulls. A vast land of beautiful ponds and marshes, populated by pink flamingos.

Van Gogh was 35 years old when he discovered the region and decided he no longer wanted to live in Paris, where he felt suffocated. "The winter is not good for either my heath or my work," he wrote to his sister, Wil. In another letter, he also said that in the south, he only had to open his eyes to capture what was there, offered to him: the trees, the hills, the bridges, the bogs and the beaches, the boats in Saintes-Maries de la Mer, farmers in the fields, and colorful gypsy caravans. Such a nomad was made for this country, and van Gogh looked happy to have finally discovered a country with sunshine, as well as an existence that allowed him to paint "with the gusto of a man from Marseilles eating a bouillabaisse." Yet the first days were not idyllic. He arrived in February. It was cold; snowing, even. However, the spring came very quickly, and the man from the north went into rapture upon seeing see the sun, the first buds, and the orchards in flower.

*Camargue, a vast land of ponds and marshes.*

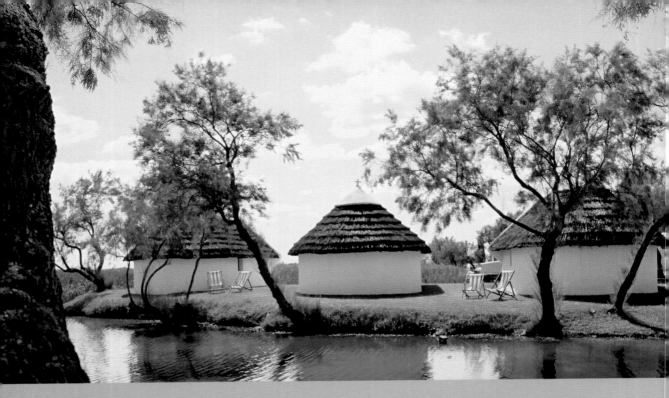

"I am working in the heat of the sun without any shade, amongst wheat fields," he wrote yet again. "Here I am, happy as a cicada…" This excitement can be found in his colors: the blues, yellows, and reds, thick and sensual, which help him to capture the daily sights. Every morning van Gogh set off, heavily loaded, to scour the area, searching for inspiration. He worked as if possessed, in a new style that literally exploded. A complete change for someone who, until then, had only painted the austere and sad. One day he decided to have his house in Arles repainted, and went off to spend five days at Saintes-Maries de la Mer. He returned with many subject themes, such as the gypsy caravan he discovered in a field where the gypsies had stopped before going off to join their annual pilgrimage on May 24. Another time he halted, bedazzled by the white farmhouses with reed-covered roofs that were home to the horses and bull herdsmen. These are also found in van Gogh's work. His most beautiful paintings were born from this intense period, when he staggered between depression, hallucinations, and disorders of all sorts. A period that remains one of his best.

Van Gogh could have painted Le Pont des Bannes. There they are: the herdsmen's houses with their roofs covered in reeds. There they are: the bogs, the famous

horses, the bulls and the herdsmen, and the country-side that witnessed the passing by of the fairground people, with their colorful caravans, each May. One experiences nature here, on horseback, in a boat, amongst the *manades* (places where horses are bred) and the gypsies. The essence of Camargue is there, authentic, mysterious, and within your reach. A region of France, yes, but much more still. Van Gogh used to say, "I do my best. I do not paint to bore people but to amuse them, to attract their attention to what is really worthwhile and not always seen." At L'Hotel du Pont de Bannes, one also takes pleasure in looking after what is really worthwhile, and what the eye does not always see.

Freya Stark was born in France, the daughter of English parents who were both painters and lived in Paris. She quickly contracted the travel bug and aspired to getting "back to nature" in the way her parents' friends, who were also artists, did. Her mother's mother used to read Greek legends to her, from books about the history of Rome and the antique myths. She spent her summers in her father's family home in England, and Christmas in her mother's family home in Italy. Soon after she was born, her parents moved to the mountains near Venice. She often said that her nomadic instinct developed on the day her father took her with him, across the Dolomites, in a basket.

At the age of 34, she decided to learn Arabic. She already spoke English, Italian, and German. Passionate about history, she wanted to go to Lebanon. She went, equipped with a copy of Dante's *Inferno*, some money, a gun, and a fur coat, as well as armed with a solid sense of adaptability and an extraordinary resourcefulness. This was in 1927. Syria, Yemen, and Iraq followed—countries where no Western women had yet been. Madcap travels that she recounted to the journalists who interviewed her in 1993, on the eve of her hundredth birthday; describing with unique vigor her trip down the Euphrates, in a raft, at the age of 84, amongst other things.

In 1954 she went to Turkey. She went there three times and wrote all sorts of books, including the extravagant *Alexander's Path*; best sellers that became vital for all the English travelers of the time, when going off to visit the far-off lands of Atatürk. In those days, Turkey was practically unknown to tourists, and just as she usually did, she traveled alone, taking little-frequented pathways to be closer to people, sometimes on horseback, or on the back of a mule, or by cab. The conditions were sometimes harsh (she was 61 at the time), yet she did not care. When Freya was young, her parents experienced a reversal of fortune, and she knew how to adapt. In addition, she did not consider being unable to wash her face for a few days

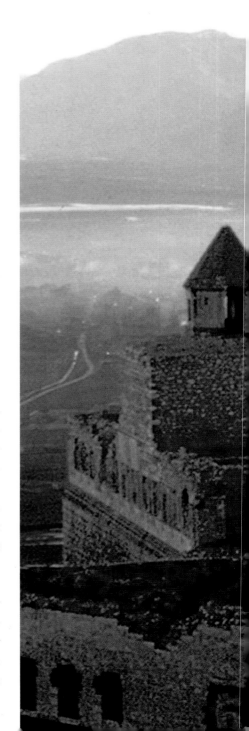

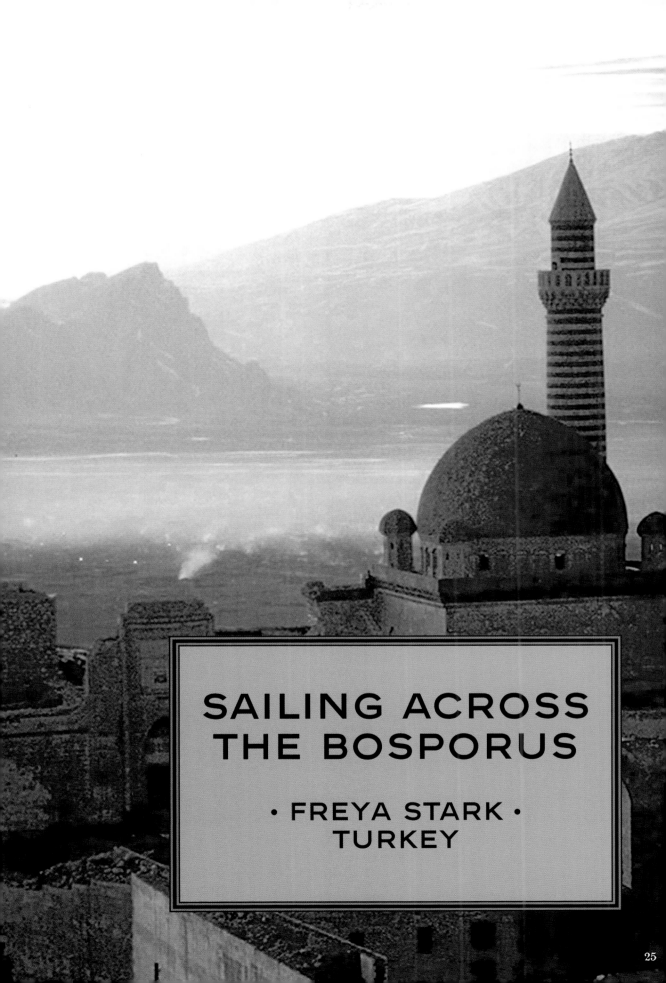

# SAILING ACROSS THE BOSPORUS

## · FREYA STARK ·
### TURKEY

an exorbitant price to pay if it meant seeing such memorable things. What was important was the intensity of the moment, the discovery, the enchantment of the novelty, and the amusement. Freya Stark most certainly had fun. Turkey was a dream straight out of the book her grandmother used to read to her; it was her way of throwing herself again into a long-ago life, and into the ancient times that fascinated her. As always, she did not go unnoticed, and all those who met her were dazed. One day she plunged into the turquoise waters, just after a shark had been sighted. On another occasion, she begged a sailor on her boat to sail toward a reputedly dangerous shore…because there were some ruins on it that she simply had to see. Once ashore, she continued her journey by cab. Cabs in which she was regularly heard declaiming Thucydides' verse, during the journey.

She enabled a good number of travelers to discover Anatolia, going where no one else had been before, into the Taurus Mountains, on the Hellenic coast, to Elazig and Erzurum, along the shores of the Euphrates, where she undertook an incredible trip on the trail of Alexander the Great and his armies. Freya Stark visited legendary sites: regions such as Caria, Lycia, Pamphylia, Pisidia,

and cities like Halicarnassus (what is now called Bodrum) and others, all conquered by the Emperor of the World, with his 40,000 men.

Although these places have certainly changed, the villages remain, and the Bosporus, the coast and its splendid yachts—from which Freya Stark was not scared of diving—were preserved. A world apart, composed of Ottoman palaces such as the Ada Hotel, a pocket of Byzantine, Ottoman, and Mediterranean arts designed by its owner, Vedat Semiz, a man fascinated by beautiful things and travel. It is referred to as the Turkish Saint-Tropez. The Riviera. This is undoubtedly due to the sophistication of the region. The hotel is above all an amazing place amidst two worlds. It is not so much the luxury, the breathtaking Turkish baths, the bedroom features, or the private beach that makes the difference. It is more the atmosphere, the location, and the subtly maintained mystery. It is the yacht, ready to go sailing on the Bosporus or to start the "Blue Voyage" (today's scenic pleasure cruise) on the sapphire waters that Dame Stark so loved. It is the antique carpets, the works of art, the magnificent library that assembles all sorts of works and looks as if it had come out of a history book. It is the crazy longing of a great traveler to build the perfect hotel.

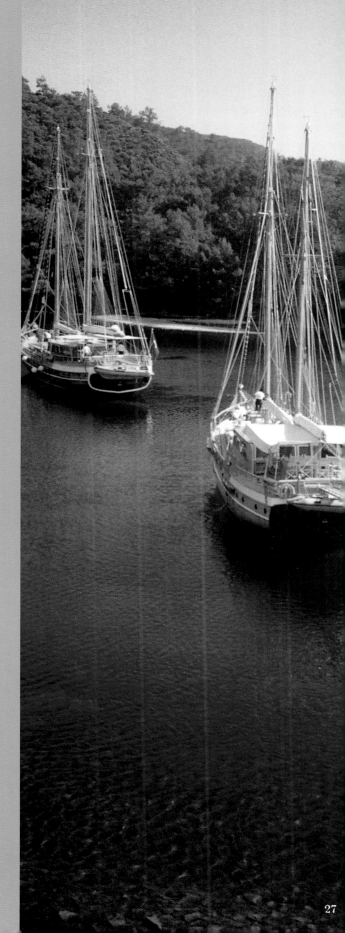

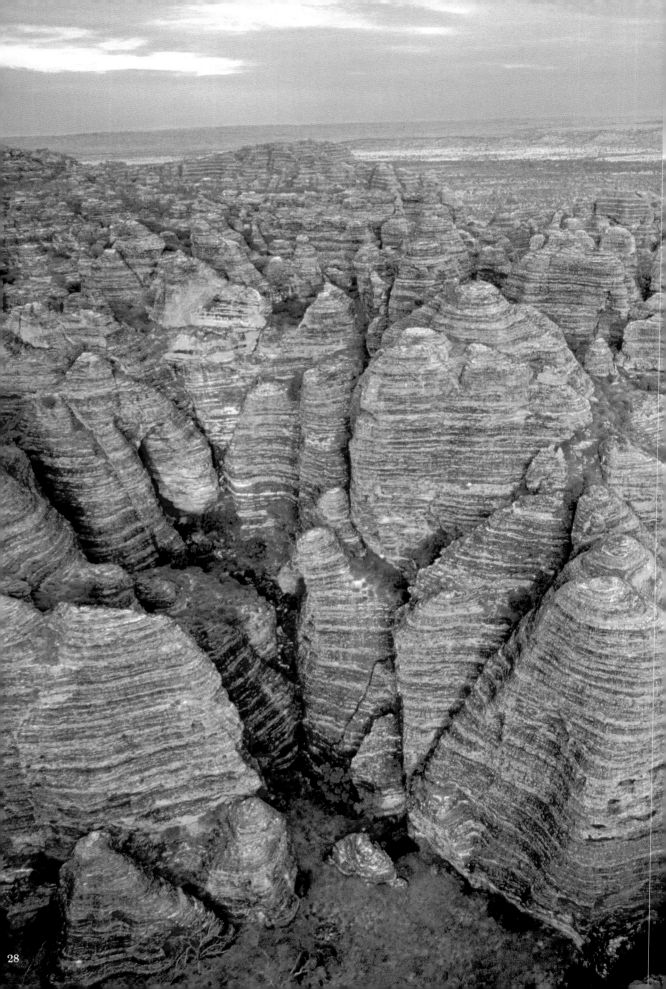

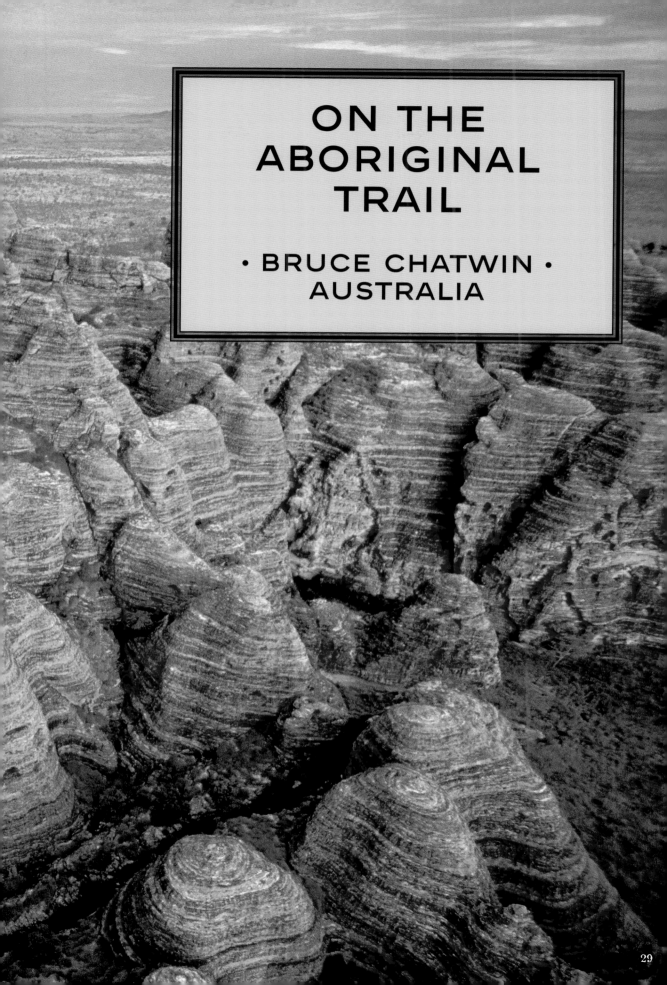

# ON THE ABORIGINAL TRAIL

## · BRUCE CHATWIN ·
### AUSTRALIA

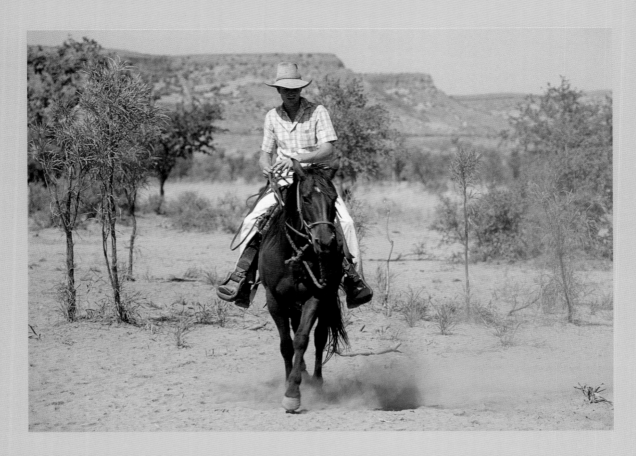

Bruce Chatwin. The name conjures up magical visions: Patagonia, with crazy landscapes and forgotten lands; the Africa and Australia of aborigines... Bruce Chatwin was every adventurer's dream. At one time or another, everyone has aspired to live as he did: with a Leica 24x36, a moleskin notebook, and a remarkable physique as sole possessions.

He started by working at Sotheby's in London, and then focused on archeology. Trips to China, Africa, and Afghanistan ensued—wild countries that allowed Chatwin to escape from what he detested above all: sedentary life. The horror of residing in just one place. A man with a multiple and charming personality, he was a fabulous storyteller and a somewhat clothes-conscious jet-setter when the fancy took him; he loved men, his wife, and himself; he died of AIDS in 1989, at the age of 48, leaving his fans inconsolable. Two years before his death, he went to Australia looking for aboriginal civilizations. The book that retraces this adventure, *The Songlines*, is much more than a mere travel story, and quite something else besides just a novel. It is the story of a nomad who, like the people he described, tried to understand what drove white men to want to "change the world and adapt it to

their vision of the future," while "the Aborigines mobilized all their mental energy in leaving the world as it is." Chatwin described the unending red land, traveled over miles and miles of tracks; farther, always farther into the outback, where only lizards and crocodiles live. Sceneries that, according to the Aborigines, were shaped by their ancestors during a period they called "Dream-Time." Apparently, they then fell asleep on the ground, forming the elements the land is made of—trees, plants, and rocks—and that today symbolize the sacred places. Chatwin went off in search of these beliefs, and of those famous "songlines." These stories

*Scenery shaped during "Dream-time"...*

have been handed down from generation to generation and commemorate the legend of creation: the animals, flowers, stones, and everything that makes our world a holy universe.

Chatwin's reality was shrouded with the fantastic, and the traveler arriving in Australia understands this instantaneously: he is in a unique land, on an island continent that resembles no other, a place where both nomads and gods met up. You feel a sort of drunkenness that is not due to the sun. Because Australia is intoxicating. The air thicker. The sun stronger. The nights quieter. When you disappear into the bush, into the outback, you are seized by a shiver of pleasure. It could be just a gigantic red desert with small shrubs and plants that defy the laws of survival. The truth is that it is so much more: an awe-inspiring, enchanting location, most certainly. It takes you by force in the way it has captured all the other elements. Hotels have been set up in the most spectacular regions. But few of them commemorate all that makes up mystical Australia—the Chatwin-style landscapes, the dust and heat, and the never-ending

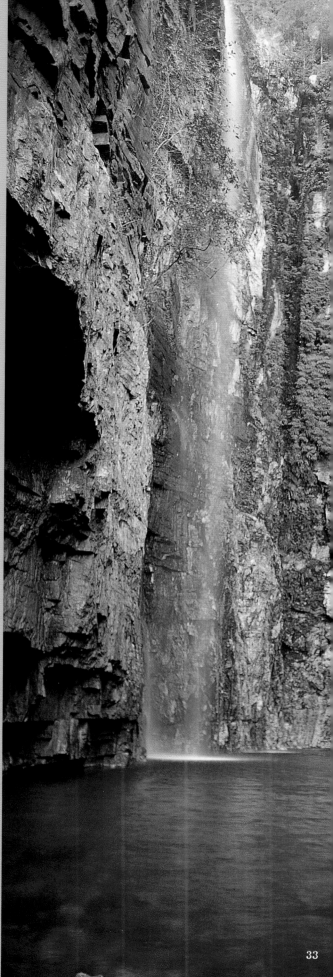

territories strewn with eucalyptus—as well as El Questro does. The ranch is located to the extreme north of the country, away from the beaten track. It is the land of the Wandjina (the Aborigines' supreme spirit being), the heart of ancient civilization; somewhere in which the modern world meets up with the legendary, with traditions that have traveled interminably since the time of our ancestors, and are found in Australian art and sculpture, in the astonishing body decorations and Rupestrian pictures. Here, nothing else exists except a dreamworld full of waterfalls, canyons, rivers, jabirus, bustards, bloodred flowers, crocodiles, and giant lizards. Kununurra, the nearest town, is about sixty-two miles away—close by for an Australian, though. This is Kimberley, a region for those who are not afraid of miles of tracks, of roads that shake you up, of sweat and dust, of action and healthy tiredness. With, at the end of the trail, El Questro, for those who still delight in bathing in hot water sources, barramundi fishing, boiling hot days dreaming of a nice beer, and cool nights in a camp majestically lit by starlight.

1923. Roger Frison-Roche is 17 years old when he finally leaves Paris for Chamonix, where he was born. He has always dreamed about this moment. He takes with him only his burning desire to live with and for the mountain. He has been offered a job as a secretary at the local tourist information center, and he is over the moon. In particular, because his office is right next door to that of the legendary Chamonix guides, and every day all he can hear is talk of ledges, abysms, massifs, glaciers, and great crevices.

An outstanding alpinist, he was chosen two years later by the famous Joseph Ravanat—the future hero of *First on the Rope*—as a porter for the ascension of Mont Blanc. His fate was sealed. He joined the legendary Companie des Guides de Chamonix at the age of 24, the first time ever for a "foreigner." An absolute dream. A unique life. He was a wartime correspondent, reporter, writer, alpinist, and photographer; he traveled to the Sahara on camelback, to Chad, and to Lapland. Fervently. Intensely…

However, he lived for the mountains. The aroma of altitude, the faces burnt by the snow, the old guides who gambled their lives on Mont Blanc, the Glacier des Bossons, the Aiguille du Midi… This kingdom of the extreme Frison-Roche presented to the world in *First on the Rope*: the story of Pierre, a man willing to take any risk to bring back the body of his father, a famous Chamonix guide struck by lightning during a race. Written in 1941 in Alger, where he was a journalist at the time—one of the numerous "adventures" of his life—the novel first appeared in serial form in *La Dépêche Algérienne*. On an off chance, Frison-Roche sent it to Arthaud, the Grenoble publisher. It was accepted. A film followed, then a second. The legend was in motion.

Chamonix and *First on the Rope* are inseparable, and you do not need to be an alpinist to approach the legendary sites, the Mer de Glace, the Aiguille du Midi, the mountain huts described by Frison-Roche, the

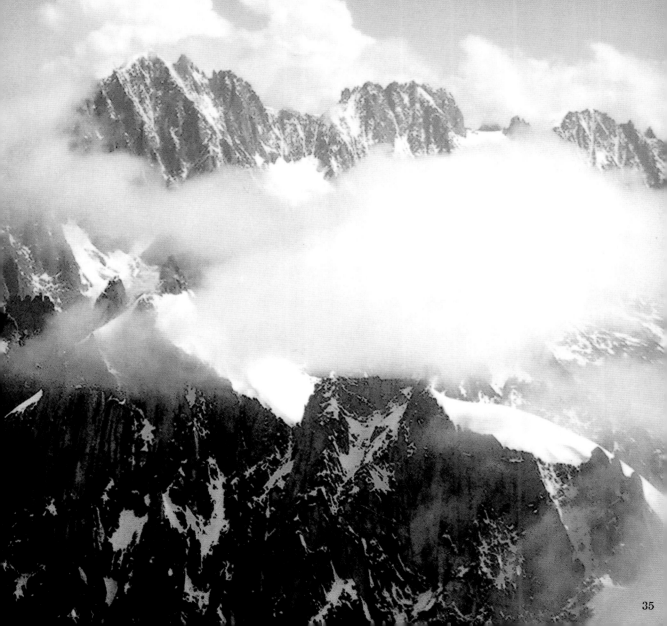

# TACKLING MONT BLANC

## • ROGER FRISON-ROCHE •
### CHAMONIX

domes, the peaks, and the famous valleys. The landscape is grandiose, and today, just like when the young Frison-Roche gave information to newcomers, the employees of the tourist information office cannot do enough to help you. Frison-Roche loved to walk along the Grand Balcon Sud trail, between Flegere and Brevent. Others prefer the Petit Balcon Sud trail, or the Grand Balcon Nord trail. Barbaric words that hide superb tracks winding between rocks and glaciers, amongst fir trees and blueberry hedges.

Since 1908, the charming Montenvers train also transports generations of alpinists and hikers up to the legendary Montenvers Hotel, unchanged since the time when excursionists visited the Mer de Glace on the back of a mule or in a porter chair. A charm that goes with the village, Argentière, its delightful chalet-hotels such as Les Grands Montets (all in wood), the typical restaurants, and a host of pleasant features. Yes, charm is very quickly set in motion here, because the stories heard are as beautiful as the scenery. Simple stories of the working men who made the region, like Joseph Carrier, grocer and owner of the Diligence (stagecoach) Geneva-Chamonix-Martigny. Carrier opened his business in 1903; it was a small family-run

hotel and dairy that he very soon called Albert 1er in homage to the Belgian King, a learned alpinist who was passionate about Chamonix. Since then, Le Hameau Albert 1er has joined the prestigious Relais & Chateaux chain, and accumulates compliments. One does not immediately realize all the work required for this, the number of Savoyard farms that had to be taken down and put up again, and the hunt for old wood in places as far as Lucerne and Friburg—a search that took nearly ten years. Everything looks as if it had always been there: the larch woodwork, the pleasant fragrance of pine, the old restaurant ovens, the mountain objects; the new and the old is reinvented and constantly updated—right up until recently, with new bedrooms commemorating the past and the future. Frison loved the place. The *Visitors' Book* bears witness to this. And in 1998, when the movie *First on the Rope* came out, the chef, Pierre Carrier, Joseph's grandson, had the joy of preparing a special menu for three hundred guests in the hotel's superb gastronomic restaurant, La Maison Carrier. Roger Frison-Roche was the guest of honor that day, "much more than any of the actors or the film director," says the chef, still quite overcome, and no one has forgotten that sumptuous meal—memorable on more than one account—washed down with a Savoyard wine, a Mondeuse 1997 Bouvet Frison-Roche vintage, of course.

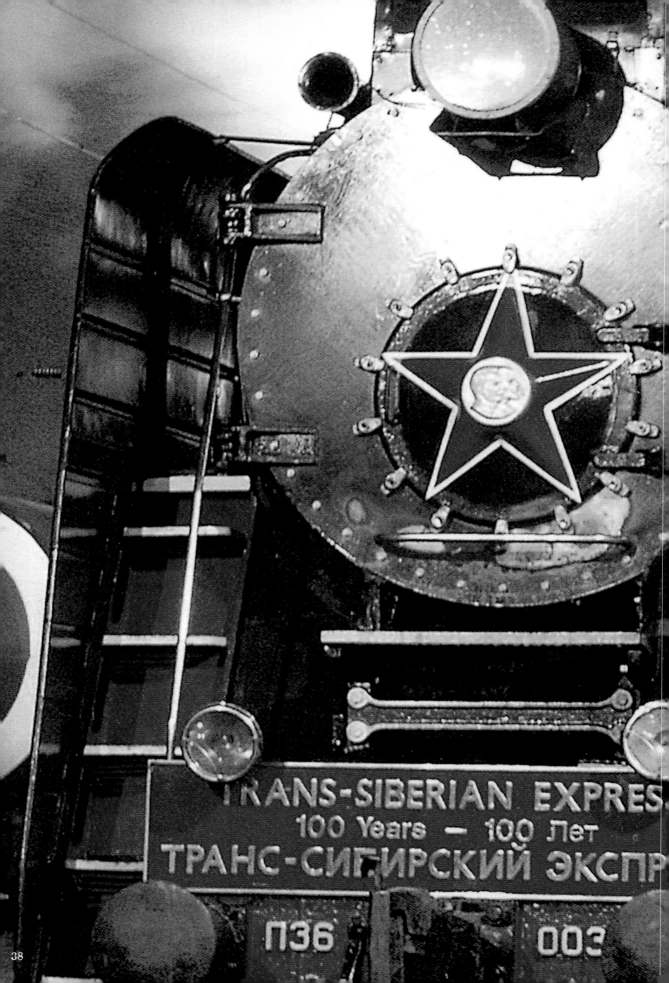

TRANS-SIBERIAN EXPRES
100 Years — 100 Лет
ТРАНС-СИБИРСКИЙ ЭКСПР

П36          003

# FROM MOSCOW TO VLADIVOSTOK, A MYTHICAL TRAIN

### • DOCTOR ZHIVAGO •
### SIBERIA

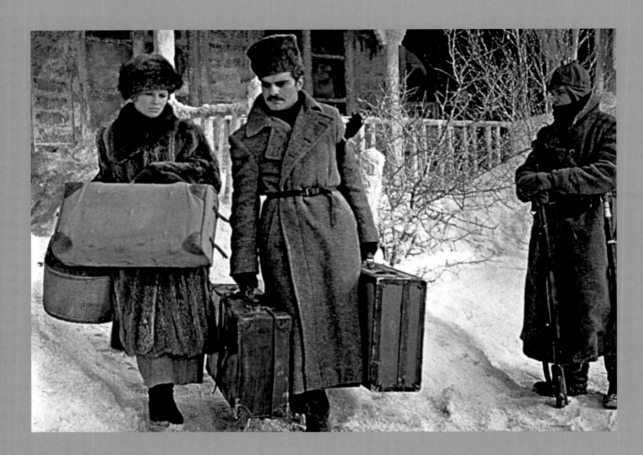

The Trans-Siberian Railway is much more than just a legendary train. It is a novel on wheels. But it also offers the longest train journey in the world, on a rail track that passes through the Siberian steppes, from Moscow to Vladivostok on the Pacific coast. It goes through eight time zones, travels over almost 6,200 miles—a third of the world—makes 91 stops between Vladivostok and Moscow, and proves that it is sometimes more exciting to go somewhere than to already be there.

The feeling of a change of scenery is the same as that experienced by Yuri Zhivago when he leaves Moscow for the Urals at the beginning of the century. Orphaned at an early age and taken in by a couple of Moscow intellectuals, his fate advances in line with that of the Russian Revolution. After studying medicine, he decides to leave the capital. There he finds Lara, whom he has met in Moscow, and with whom he has fallen in love. This story is the author's story, that of Boris Pasternak and Olga Ivinskaya, a tragic beauty who paid for this mad passion with eight years of Gulag, ending her life in a miserable flat in Moscow. Pasternak was already famous when they met. He was married, and twenty-two years older than she was. She was beautiful, twice widowed with two children, and had been through all the drama of life and war. They met in 1946 in the *Novy Mir* magazine offices, where Olga worked as a secretary. Pasternak fell in love with her and immortalized her in his novel. The regime was unable to stop the book's success. Moreover, Pasternak was protected by Stalin and was awarded the Nobel Prize shortly afterwards. So they took revenge on Olga. The Gulag, the humiliations, the misery, nothing made a difference. Olga will forever remain the stunning Lara.

The train carrying the Zhivago family out of Moscow was traveling eastwards, through wintry landscapes,

*A myriad of fascinating features...*

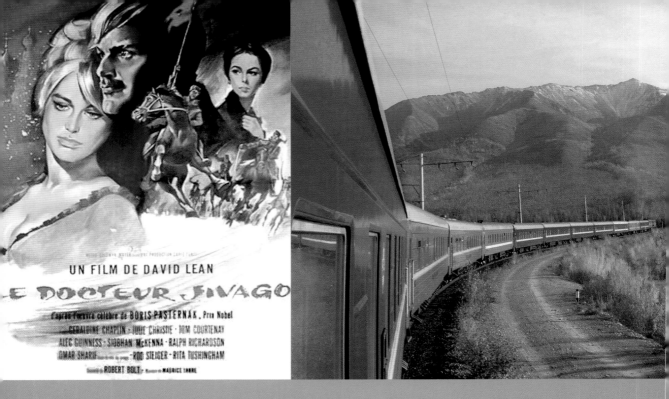

through fields, forests, and regions where armed bands laid down the law. The young doctor saw wagons that "showed a colorful sight. Besides well-dressed rich folk, bourgeois, and lawyers from Petersburg, there were also, all together in the same boat, carriage coachmen, floor scrubbers, public bath attendants, Tartar secondhand clothes dealers, small traders, and monks..." At one time, they had to clear the track for the train, immobilized by snow. This took three days, and everyone got out to give a hand. "The days were clear and cold. We spent them outdoors. We only returned to the wagons at night." These are regions where the landscape changed rapidly. "Suddenly everything had changed, both the land and the time. The plain vanished, and we disappeared into the hills. The north wind that had been blowing

until then, fell. The wind blowing from the south was as warm as an open stove."

The Trans-Siberian Express goes through Yaroslavi, one of the oldest Russian towns; Ekaterinburg, where the Tsar Nicholas was executed by the Bolsheviks; Krasnoyarsk; Ulan Ude; and Khabarovsk. Ahead of its time with luxury wagons from the twentieth century, the Trans-Siberian Express breathes eternal Russia, and this is magnified in David Lean's film. A keen photographer, convinced of the influence of the environment on the human personality and a tireless traveler, he was unable to shoot the movie in Russia, so he rebuilt Moscow in Madrid, and Siberia in Finland. A crazy collection of details, costumes, and decors for a lavish three-hour epic. The train journey through the Urals. The Urals, the arrival at the Varykino Ice Palace, colors that are out of this world, the nostalgia, and the most extraordinary scenery in the world re-created on film. The movie is truly poetic. The Trans-Siberian Express also, with its decor that blends ancient and modern, its caviar, Russian champagne, vodka, and traditional menus concocted randomly with each stopover. A mosaic of details that always fascinate, as fantastic as the time spent in the steppes.

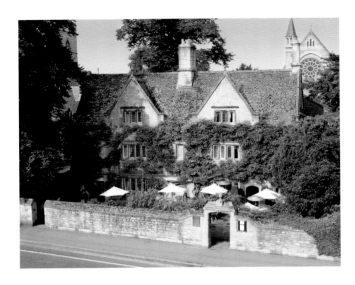

If the Old Parsonage Hotel in Oxford is not mentioned in a Harry Potter story, it is because nobody has told the author to what extent it is unique, remarkable, secret, and infinitely endearing. A magical place, whose charm comes from a complex alchemy combining the architecture of a seventeenth-century presbytery with fairy-tale features. You will find here magnificent old-stone chimneys, medieval doors, plump armchairs, freshly made scones for afternoon tea in the restaurant, bouquets of freshly cut flowers, masses of friendly smiles, and bicycles to discover the area, just like the students in their black gowns. The hotel does not have a lot of bedrooms, but they are all as pretty as a picture, with windows opening out on a delightful parish garden, and the flowerbeds of an interior courtyard.

How do you get there? Take the train from King's Cross station in London, platform 4 or rather 9 3/4, and within the hour, there you are, in the midst of schoolboys in coat frocks and sassy schoolgirls with blazers. The best-educated "Muggles" on the planet. By the magic of Warner Bros, Oxford University and, more specifically, Christ Church (a ten-minute walk from the hotel) became Hogwarts, the School for Sorcerers. The Divinity School, built during the 1420s, was turned into the infirmary. Harry and Hermione looked for the secret of the philosopher's stone in the Bodleian Library, a masterpiece of Gothic architecture. Professor McGonagall welcomed the sorcerers' apprentices for the first time at the top of the monumental Christ Church staircase, dating from the sixteenth century. The enormous dining hall can be seen just after the staircase, that famous refectory with its magnificent stained-glass windows, ancient paintings, and woodworks, untouched since 1529. During your visit, you can see where Harry Potter, Hermione, and Ron wandered, near the tables laid for students who have supper here in the evening. In 1855, Lewis Carroll was a mathematics professor at the college and wrote *Alice's Adventures in Wonderland* there. The secret doors, the keyhole that allows one to enter Wonderland, the fantastic gardens where the real

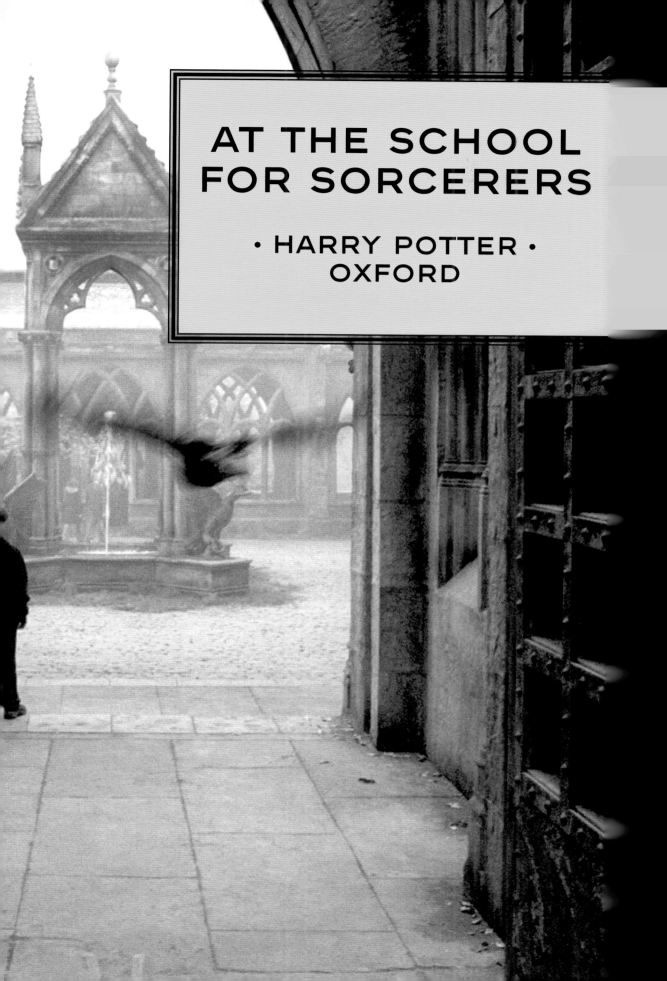

# AT THE SCHOOL FOR SORCERERS

## · HARRY POTTER ·
OXFORD

Alice used to walk—everything is still there, unchanged, or almost. This is what the fascinating guide, Tony Fox, tells you. He knows innumerable stories about the place, about Lewis Carroll and Harry Potter, answering all your questions with the enthusiasm of a mischievous child who is delightful to watch. The walk is not banal. Neither is the place. When you go into the halls dating from the Middle Ages, or into the gardens that appear as you push open an old creaking door, you get the impression that you are discovering places that hide a multitude of secrets, a reserved domain full of mystery. Everything seems to be strange and unreal. The beauty of the setting has a lot to do with this. All the visitors tell you that. Oxford is magical. Its superb architecture, its adorable English gardens that grow everywhere, its charming boutiques, and its little paved pedestrian roads… Here, every road, every building, every interior courtyard, and every door has a story to amuse both adults and children. The Old Parsonage Hotel's heavy oak

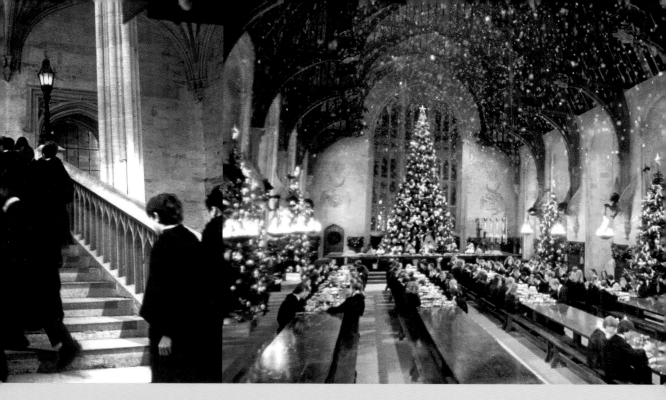

door is no exception to the rule. It, too, opens up a thousand stories. It is said that the hotel cellar shelters the remains of a secret passage well-known to priests hoping to flee from persecutions, and that the ghost of a nun has been seen in the oldest part of the house. Oscar Wilde apparently lived there also for a while, in room 26, just above the Reception, when he studied at Oxford. But the Old Parsonage Hotel does not reveal its stories to everyone. They are discovered one by one, by reading one of the pretty brochures or by chance during a friendly conversation. You have been warned: this is a hotel that is both unique and magical, worthy of the *Chamber of Secrets*.

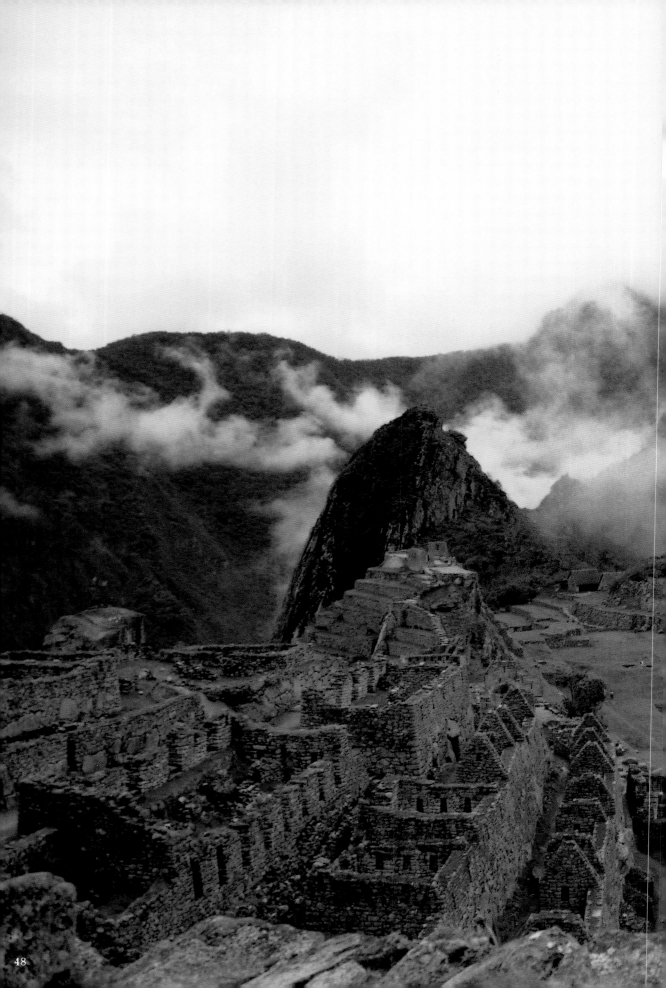

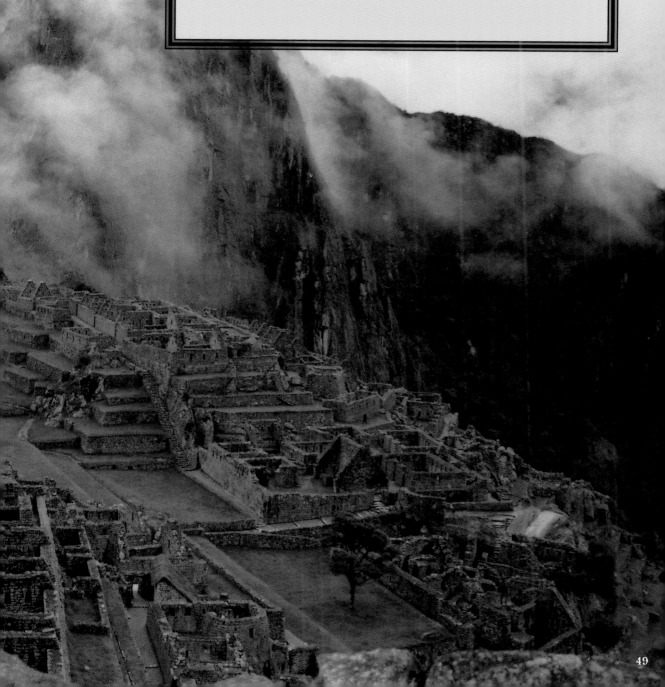

# ON THE INCA TRAIL

## • HIRAM BINGHAM •
## MACHU PICCHU

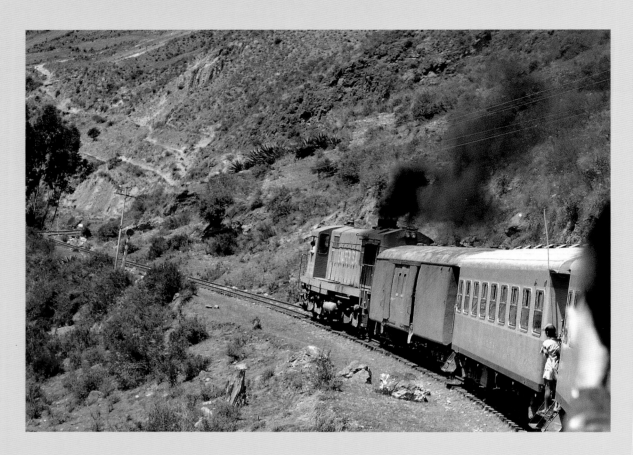

Being the first to find this fabulous Indian city was, for many centuries, the dream of every conquistador and archeologist in the world. Neither achieved it, and it was only discovered in 1911, quite by chance, by a young teacher of Latin American history .

Hiram Bingham was 36 when he decided to launch his expedition with the help of a grant from the National Geographic Society. He had waited three years, and finally, there he was, in July 1911, about to succeed. He had only an old map to guide him, and approximate information, but he believed in his luck. He was sure that considerable traces left by populations decimated by the conquistadors existed, and nothing could stop him. One evening, when he had stopped for a well-earned break, a farmer told him about some ruins... An ordinary conversation. An incredible chance. The next day, July 24, Hiram Bingham went off with the farmer and a translator to look for these ruins. They experienced the worst possible difficulties going through the jungle, climbing up weed-invaded slopes, and keeping their sense of direction as best they could amongst creepers and snake-infested plants while walking toward the summit. At the time, the area was practically unknown to geographers.

And even less known to the rest of the world. After reaching a village, he continued his ascension, accompanied this time by a 10-year-old child. In his excitement, Bingham said he forgot his tiredness and walked along a terrace until he reached the jungle. He entered the humid undergrowth and then stopped. There in front of him was a moss-covered wall... The sight did not dash his hopes. Behind the wall appeared the largest Inca city ever discovered, quite unique, and dating from the end of the fifteenth century; it clung to a narrow crest between two peaks. Dazzled, Hiram

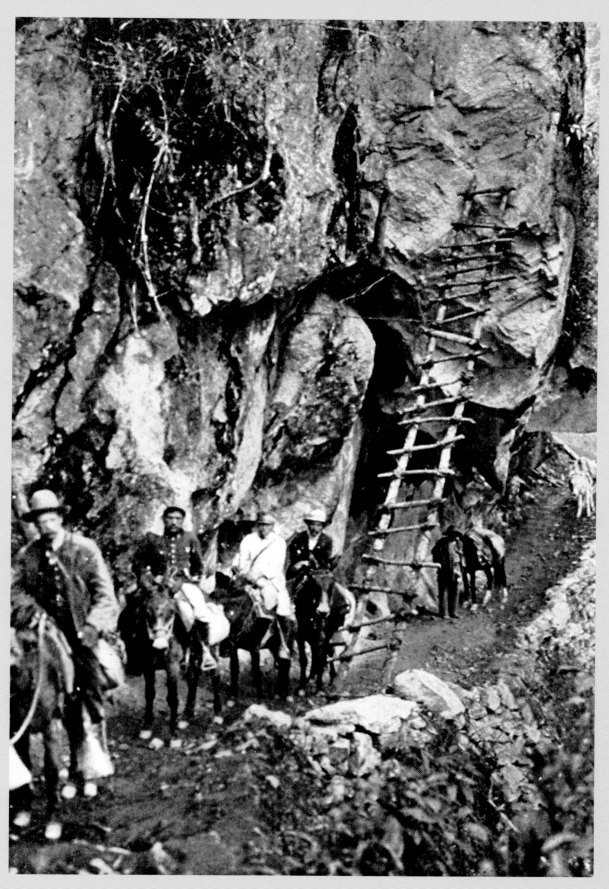

*Urubamba Canyon during the expedition to Machu Picchu around 1911,
a road that dreams are made of...*

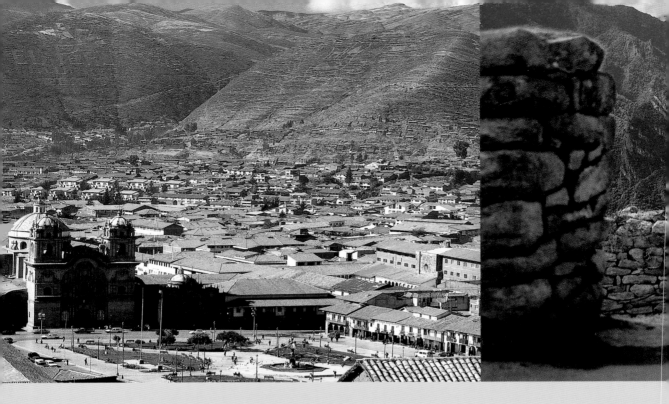

Bingham traced the contours of the ruins invaded by plants with his hand; fascinated by the sight of the stone houses on the sides of narrow streets, by the walls, the staircases, the towers, the windows slowly appearing from the mist; taken aback not only by the state of preservation but also by the perfect harmony of both the architecture and the landscape. Nobody had ever seen anything quite like it…

He first described his fabulous adventure in 1913, in a special edition of the *National Geographic* magazine, then in a book that became a best seller: *Lost City of the Incas*, where he wrote, "I know of no other place in the world which can compare with this."

No excavation to date has thrown any light on the mystery surrounding the construction of this extraordinary granite city above the gorge of the Rio Urubamba. The five hectares of terraced fields, the thousands of steps, the temples, the blocks of carved stone resembling solar calendars: everything is remarkable and enshrined with mystery. The Inca Trail, opened by Hiram Bingham during his expedition, has become a famous road that travelers all over the world have dreamed of taking to visit the lost city. It goes through fantastic sceneries lined with the remains of archeological sites, some of which have been cleared only during the past few decades.

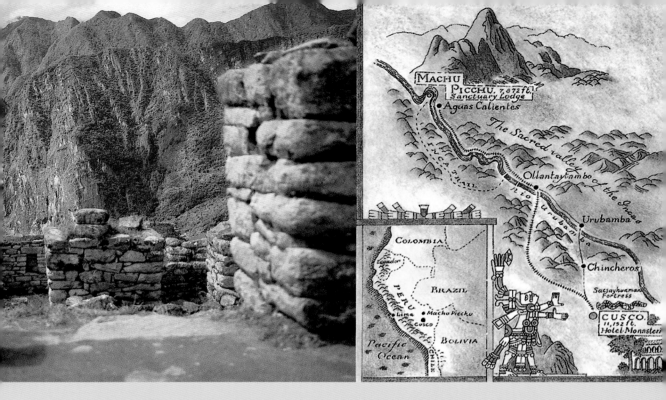

The Hotel Monasterio, an authentic sixteenth-century monastery in the heart of mythical Cuzco, "the navel of the world," reminds us of the time of the conquistadors, of Hernán Cortés, who attacked the Aztec kingdom, and of Pedro de Valdivia, who founded Santiago in Chile before being massacred by the Araucanian Indians. From there you set off by train, or on horseback, or trek for several days over mountain slopes, on the Inca trail, camping along the way just as Bingham did, as far as Machu Picchu Pueblo Hotel right at the top, only a few seconds away from the ruins. The Hotel Monasterio is the first stage of the journey, close to Plaza de Armas. A truly royal place to halt and an exceptionally elegant oasis, with its meticulously cared for patio, its baroque chapel tottering under the weight of gold—where you can get married, with its bedrooms hidden under great solemn arcades. From its windows, you can see the picturesque San Blas district, the surrounding holy mountains, and everything else that makes up the magic of the ancient Inca capital. Inside, old paintings take you back in time and evoke great periods of history, fierce wars, fighting losing battles, and frightening demons from hell. This hotel-museum, with its decor from distant colonial eras, welcomes visitors today just as it welcomed priests some three hundred years ago.

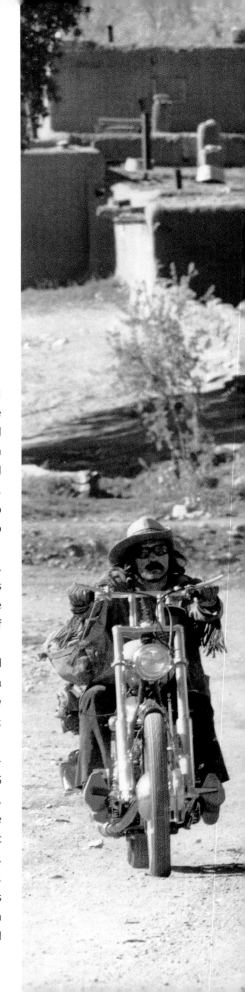

When it came out, everyone said it was a film about hippies who were high: a bunch of stoned lunatics. A shock for the Puritan America of the day. The owners of major studios were all granddads who only liked sentimental comedies and war films that glorified the values of an ideal America. In 1968, the head of Columbia even refused to produce *Hair*. Things changed with the Vietnam War, the baby boom, Martin Luther King, and Woodstock. *Easy Rider* is a bad trip through the United States. A road movie about two idealistic bikers who transport cocaine over California roads and end up assassinated. It is also a first film for a crazy and arrogant novice.

Under the influence of dope, entranced by Colt 45s and Bourbon whiskey, Dennis Hopper dragged two other smashed nutters along with him in his hallucinatory delirium, namely Jack Nicholson and Peter Fonda. The movie was inspired by the life of Earl Z. Finn, a friend of the trio, the King of Adventurers, who now creates the most recognizable custom Harleys.

The movie won Hopper an award for Best First Work at Cannes in 1969, and it was crowned, at once, the ultimate cult movie. An avalanche for America at the time, with a soundtrack that included "Born to be Wild," by Steppenwolf; "If 6 was 9," by Jimi Hendrix; The Byrds; Jefferson Airplane; Procol Harum; the Moody Blues… The cream of rock.

Mexico, Ballarat, a Californian ghost town, Needles, Bellemont (in the middle of the sticks, in the region of Flagstaff, in Arizona), the mythical 66 Highway, Monument Valley, Krotz Springs, Las Vegas in New Mexico, Taos, Santa Fe, New Orleans… The road taken in *Easy Rider* has conjured up the legend of America for over thirty years: traveling through the wildest deserts, through nameless villages, canyons and sierras, immense red plains, and through astounding sceneries that nearly take your breath away. Coming across strange motels in the middle of nowhere, and snack bars from the fifties, old neons on the 66 Highway—the "Mother Road"—Indian reserves, wooden houses similar to those shown in western movies, and

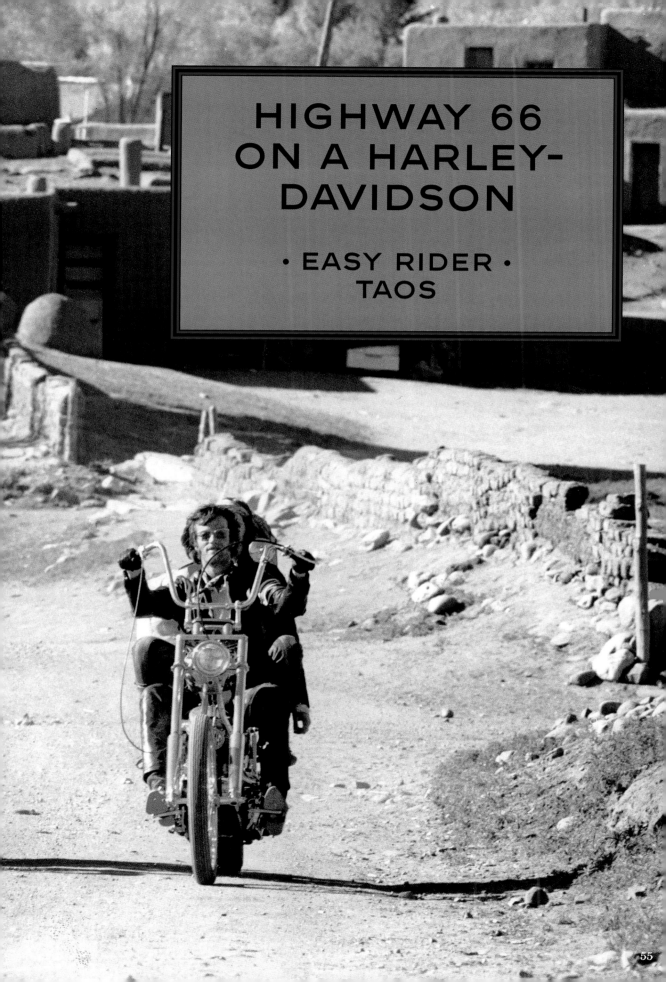

# HIGHWAY 66 ON A HARLEY-DAVIDSON

## • EASY RIDER •
### TAOS

kitsch bars; all this in the heart of the mountains that made the history of American West. The Pine Breeze Inn in Bellemont, where the bikers were turned away in the film, welcomes all bikers who stop off nowadays. Nothing is easier than renting a Harley in Los Angeles (or from any Harley dealer in the region) and hitting the road from the City of Angels to New Orleans.

Taos has remained the small pueblo it was back in the native Mexican era, with multilevel flat-roofed adobes that have been lived in for over 1,000 years. The oldest houses in the United States. This is New Mexico, an odd kind of place, which only became a state in 1912. With a mixture of Indian and Hispanic influences, a land dedicated to the glory of creation, to bohemian culture, and to all rebellions. During the shooting of his movie, Dennis Hopper stayed at the Mabel Dodge Luhan House, a hacienda built by New York artist Mabel Dodge and her Indian husband, Tony Luhan. Hopper purchased it with the money he earned from the film, and turned it into a temple for all excesses. An empire of chaos and drugs, it became an ideal hideaway for his friends from Los Angeles: Leonard Cohen, Bob Dylan, Joni Mitchell, Kris Kristofferson, Alan Watts, the Everly Brothers, the *Easy Rider* group. A psychedelic sanctuary

worthy of *Rolling Stone* magazine, one very different from that created by Mabel Dodge, with D.H. Lawrence, Martha Graham, Georgia O'Keefe, Aldous Huxley, and some others.

The film made other hippies go to Taos; they loved it and stayed there. They opened art galleries, delightful craft shops, pretty restaurants, and charming hotels. Behind the massive door, Mabel and Tony Luhan's hacienda remains a paradise for artists, painters, writers, poets, and fertile imaginations. The memory of colonial Taos is carried on, as well as Mabel's ambition—with the place's art workshops, meditation days, and isolated location (far away from the towns), ideal for reflection and creation. The thick adobe walls, the purest Mexican style decor, the blankets and traditional Indian potteries, the patio that always has flowers, the cool and isolated corners in the shadow of the old beams, the small tiled *placita*… D.H. Lawrence painted immense multicolored stained-glass windows in one of the bathrooms. Georgia O'Keefe loved the quiet little room on the first floor, overlooking the patio and the large portal. Mabel lived right at the top, with a spectacular view of the mountains. Dennis Hopper preferred the "Ansel Adam Room," with its semi-private patio and large bed, where he could stay for days on end.

# MEETING GORILLAS

## • DIAN FOSSEY •
### RWANDA

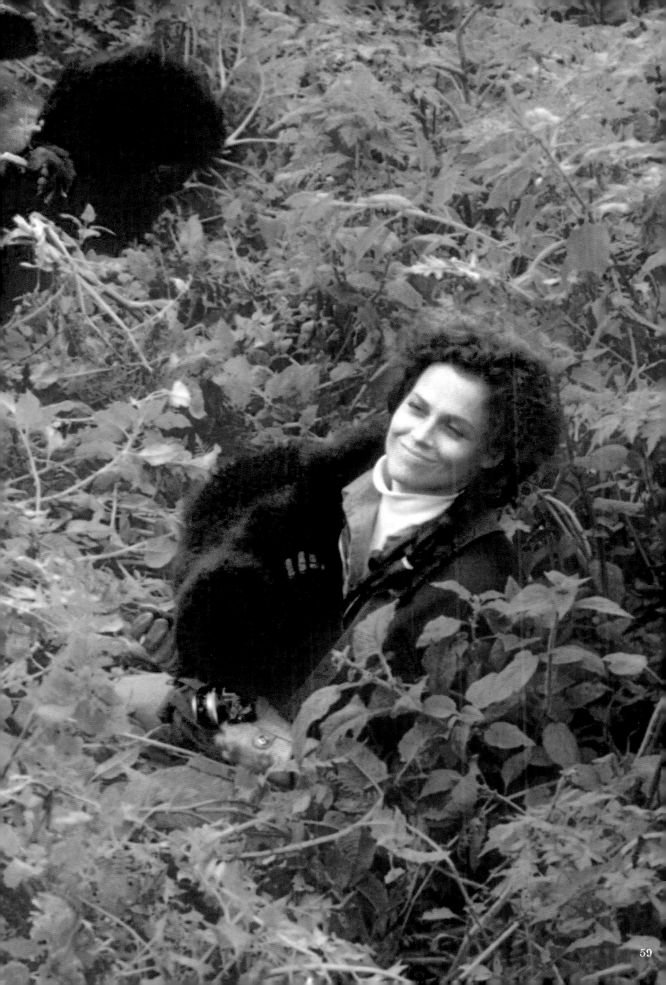

"Neither destiny nor fate took me to Africa. I had a deep wish to see and to live with wild animals in a world that hadn't yet been completely changed by humans."

Dian Fossey was 31 and had never set foot in Africa when she decided to go to Tanzania to meet the famous anthropologist Louis Leakey. She had failed her veterinary studies and was working in a children's hospital in Louisville, Kentucky. "Another of those bothersome tourists," said Leakey when he saw her coming. The contact was brief but decisive for Dian. Three years later, in 1966, Leakey came to a conference in Louisville to present a survey project on apes, which he thought likely to explain human evolution. He was already working with Jane Goodall, who was fascinated by chimpanzees. He wanted to add gorillas to the list. He described the ideal colleague, namely a woman (less intimidating for the local population) without any specific training, with no responsibilities, and single. But with, above all, determination. Dian got the job.

Her parents disapproved, but she could not care less. She first went to the Congo, then on to Rwanda when the war broke out. Determined, untiring, with unfailing patience, she obtained grants from the Wilkie Foundation and the National Geographic Society. She never imagined at the time that three year's later she would actually be on the cover of *National Geographic* magazine... The famous cover page that transformed her into a legend was followed by numerous homages, great coverage, and the making of documentaries throughout the world. She fascinated millions of readers, and this enabled her to

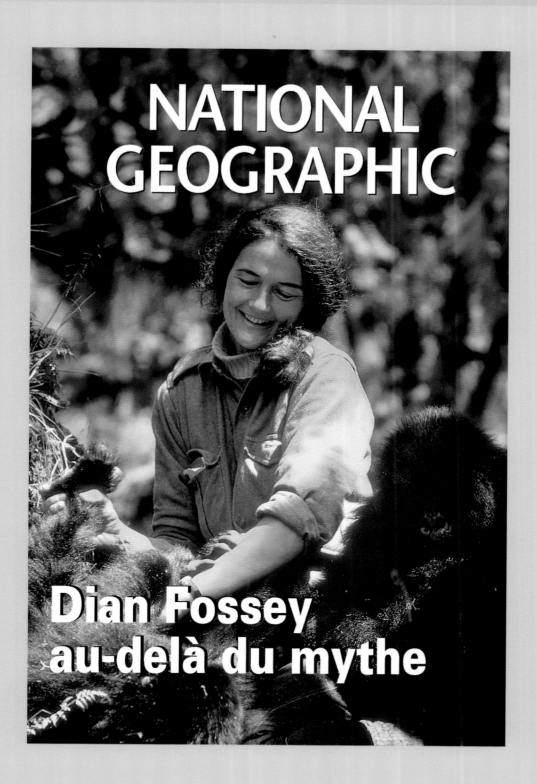

# NATIONAL GEOGRAPHIC

## Dian Fossey
## au-delà du mythe

successfully complete the work of her life, the Dian Fossey Gorilla Fund International. Karisoke, her study camp, is located in the Parc National des Volcans. It is only a log cabin in the misty forest at over 9,800 feet of altitude. Dian lived there for eighteen years under tough conditions. She put up with everything. Slowly, cleverly, she gained the trust of the gorillas, mixed with them, imitated them in order to better approach

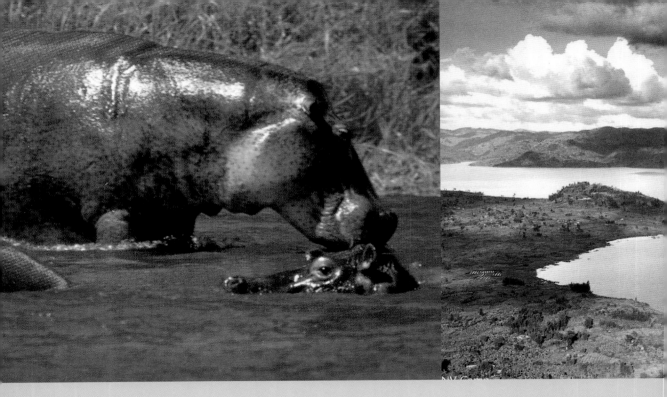

them, until this famous day in 1970 when, after years of waiting, Peanuts, a male adult, came to touch her hand. This was the first friendly contact with a human made by a gorilla. Dian's companion at the time, Bob Campbell, a photographer for *National Geographic* magazine, took some superb shots of these incredible moments that Dian relates in her memoir, *Gorillas in the Mist*. She was found dead in her cabin two years after its publication.

*Gorillas in the Mist*, Michael Apted's motion picture, was partly shot on the very location where Dian Fossey observed the gorillas. Sigourney Weaver played the role of Dian with stunning conviction. The movie crew set up a base camp in the mountains at 8,500 feet, and a smaller group then climbed to 11,800 feet in order to reach Dian's observation point—the government had limited the number of people, to preserve the animals. Farsighted, the film director had taken Sigourney Weaver to the location before shooting to ensure she would not flee from the forest, screaming. Once again, the film allowed millions of spectators to discover Dian's fantastic work, as well as a small country in Central Africa, the then unknown Rwanda. The "Country of a Thousand

Hills," is today healing its wounds and wants to show the world its gems. The magnificent Parc des Volcans, nestled in the Virungas Mountains, is the last refuge for mountain gorillas, threatened with extinction. Approaching them is, without a doubt, the most moving experience that one can have in Africa. Travelers can see mothers with their young, and groups of over thirty enormous male adults—naturally pacific, as Dian showed—only a meter away. The adventure starts at Virunga Lodge (a pretty group of typical houses, recently built on the mountain), about three hours away from Kigali, with a spectacular view of the volcanos as well as of lakes Ruhondo and Bulera. The hotel team knows the area by heart and organizes a whole range of amazing expeditions in the region, astounding all those who long to see and experience something quite different. These adventures require patience, endurance, a definite taste for walking, and a strong yearning for the extraordinary. The team also permits you to approach the gorillas and even to go right up to Dian's camp. This is quite an experience. A fabulous yet curious moment, as if time has just stopped… Treading the same ground that travelers tread today, Dian described that magic moment: "I will never forget my first encounter with the gorillas. I heard, I felt, before seeing anything: firstly the noise, then a powerful musky smell. A farmyard smell, but at the same time, an almost human smell."

MARTHA
GELLHORN
A LIFE

'Engrossing...Biography and memoir are *the* forms of today and Moorehead's book is vibrant proof of that' Rose Tremain, *Guardian*

V

Of course, she was Hemingway's wife, his third. But she was also a journalist, writer, and wartime correspondent. A beautiful blonde bombshell, chic and well educated, determined to make a name for herself in a man's world at a time when nothing made this easy. She was one of the first women to write about the Normandy landing, and about the concentration camps.

She met Hemingway at Sloppy Joe's Bar, in Key West, in 1936. The attraction was mutual. She had class, which pleased the old bear. She had been married to a Frenchman, Bertrand de Jouvenel, had lived in Paris, and nothing stopped her. She and Hemingway took part together in the Spanish war, argued constantly, were jealous of each other, and after five exhausting years, she left him. She was the only woman to do so.

In 1941, they set off to cover the Sino-Japanese war. She, for the magazine *Collier's*, he, for *PM* magazine. A nerve-racking 30,000-miles journey via Hong Kong, the banks of the Yang-tse-Kiang River, Tchong King, the Mekong River, Mandalay, and Yangon. Difficult days on potholed roads, amidst landscapes devastated by bombardments. To begin with, Martha was hardly enthusiastic. They traveled by sea, by air, over land, spending sometimes up to twenty-five hours on a dilapidated train, or over forty hours in an old tub, before catching something that vaguely resembled an aircraft. However, she had always wanted to see Asia. In addition, U.C., her Unwilling Companion, as she called Hemingway, adored hearing the locals tell their tales. Particularly when they were implausible. Better still if they were copiously "washed down." Four days after her arrival in Hong Kong, Martha decided to go and see the famous Burma Road alone. Over 717 miles from Kunming, in China, to Lashio, in Burma, giving the Chinese an access to South East Asia, and to the Indian Ocean. She climbed into an old crate. The contraption, without any air-conditioning, or pressurization, flew over the famous road

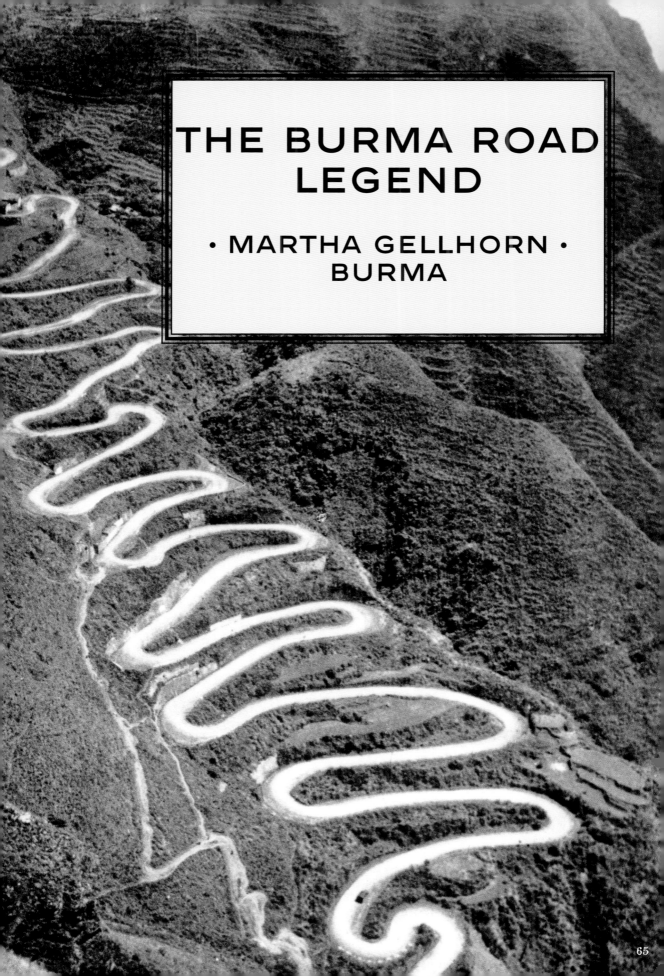

# THE BURMA ROAD LEGEND

## • MARTHA GELLHORN •
### BURMA

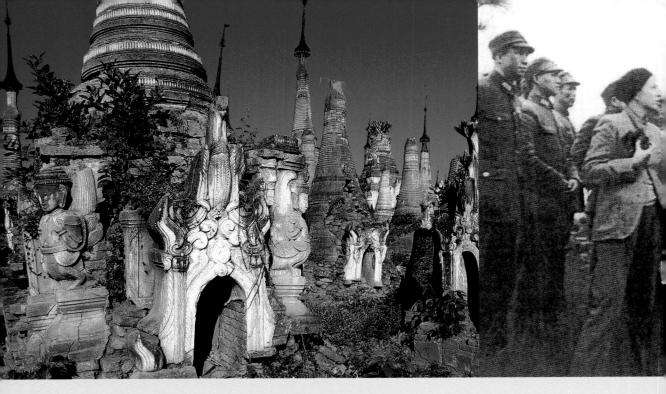

amidst an awful gale that made it go up and down like a lift. More than an hour of this nightmare across masses of clouds "as dark as granite," with, for only comfort, the good will of a pilot who knew how to land without visibility. Martha only discovered the famous road on her return journey, a region that she declared was magnificent and hopeless.

The journey continued toward Shaokwan in an old Chevrolet, then in a lorry, a rustic Chriscraft, by train, by boat, by plane once again…until the last stop of the trip, Yangon. A haven of peace and unhoped-for luxury where, unhappily for her, it was indescribably hot. She felt that one could cut the heat and hold it in one's hand like a piece of wet blotting paper… Impossible to sleep. The only way to sleep, or even to live, was to lie down naked on the marble floor, under the ventilator, in the hotel bedroom.

Which hotel? It might have been the Strand, a legendary sanctuary of the British colony that has welcomed everybody since 1901: Orwell, Kipling, Coward, Maugham, kings and rockers… Who has not walked over the marble and teak floor? Who has not collapsed into one of the large cane armchairs? Who has not sought the refreshingly cool bar, while sipping

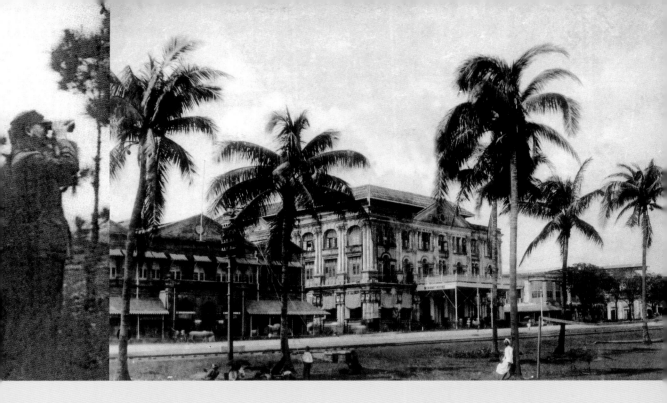

a martini under the blades of the ventilator? The recent refurbishment has not destroyed the charm. Those who want to see Burma, now Myanmar, Mandalay and its pagodas, the famous Burma Road, the breaks in Martha and U.C.'s travels, start out from there. You only have to read her memoirs again, *Travels with Myself and Another*, and trust the guides. The Japanese who occupied the hotel at one time transformed part of it into stables for their horses. Martha would certainly have included it in one of her articles. She would not have missed the opportunity of adding that, from there, one had the best view of the Flying Tigers diving at full throttle onto the Japanese.

If he had not been so intelligent and so funny, the great Ella Maillart said she would never have gone anywhere with him. His sense of humor was devastating. Laughter was his master trump card. How can anyone resist such a character? Charming, elegant, more resourceful than anyone else, a *Times* correspondent, Peter Fleming was Ian Fleming's brother—who used him as an inspiration for James Bond—and he was determined not to resemble his Eton friends who had traded wearing colonial helmets for top hats. He adored risk, uncertainty, and anything that people declared quite impossible. He never took himself seriously. Moreover, one word was enough for him to get up and go. This time, it was a small ad in the *Times*...

"Exploration and hunting expedition, under experienced management, leaving England in June to explore rivers in the center of Brazil and if possible specify the fate of Colonel Fawcett. Abundant small and big game. Exceptional fishing. Room for two more guns. Good references mandatory." Enough to make Peter exultant. This was his favorite type of ad.

The year was 1932. He was 25 years old. He wrote to the paper, and to his great joy, he was accepted. So, off he went on the tracks of the famous Colonel Fawcett, who had disappeared in 1925 in the Brazilian jungle. He did not talk about it much, not wanting to be considered a madman, or taken for a hero, when he considered this trip to be simply an exceptionally long holiday... After some preparations in London—looking respectfully at photographs of all the fish, dead and alive, you could possibly imagine—the small team set off. A team constituted with people who could hardly be taken for explorers, even at a cocktail party. Little by little, the characters emerged. The wardrobes too; some members succeeded too well in their search for the picturesque, with anti-mosquito boots, and cartridge holder belts bursting from their luggage. They went from boats to lorries. Every move requiring local help was put off until the next day, perhaps, *Si Deus quizer*... The expedition finally entered the virgin forest, amongst blue and golden macaws, toucans, *carapatos*—ticks about which

# SURVIVAL IN THE BRAZILIAN JUNGLE

## • PETER FLEMING •
### AMAZONIA

the team had heard quite a lot, and not favorably— coatis, piranhas, and *jacares* (alligators); it went through small lagoons, beaches, Indian villages; it crossed walls of greenery and branches, silent rivers, by dinghy or by foot, under the boiling sun, applying Sherlock Holmes's methods to Robinson Crusoe's data. Nothing more was found regarding Colonel Fawcett, and the group finished its incredible epic in front of some Lisbon customs officers alarmed by their moldy shoes, filthy shirts, and luggage overflowing with fetid souvenirs... Their complexions were obviously not seasonable, and their clothes bore what the police would usually refer to as "signs of violence."

*Brazilian Adventure* is full of details about this crazy journey. A must for every traveler...and proof that not all adventurers consider themselves to be heroes.

Those who have been to Ariau Amazon Towers and read the book will smile, of course. Peter Fleming traveled farther east, but the hotel is situated in the same thick jungle with black rivers, dinghies that sail through muddy waters, macaque monkeys, caimans or *jacares,* toucans, piranhas... Creatures that would

fill up whole encyclopedias. Commandant Cousteau gave the hotel's owner, Francisco Ritta Bernardino, the idea of building this astounding place right in the middle of the Amazon. A pioneer of ecotourism determined to make known and preserve this extraordinary environment, he designed bedrooms set in towers that would border the Rio Negro. Thus, three hours away from Manaus, one can see houses integrated into trees—Tarzan houses—with incredible footbridges connecting the buildings with the forest. A ladder goes from the houses right up to the top of the trees. From there you have a bird's-eye view of the world. A sea of leaves, branches, blue sky, and an overwhelming sense of freedom. No mosquitoes, thanks to the acidity of Rio Negro. No newspapers, no fax machine. Just travelers amazed beyond all their dreams, mingling with Indians, with the forest, the rivers, with terrapins, butterflies, tapirs, *jacares*, snakes, spider monkeys, agoutis, manatees, pink dolphins. Giant water lilies, birds, trees, plants, flowers, and a thousand species of animals, just as in real life, in the most natural way.

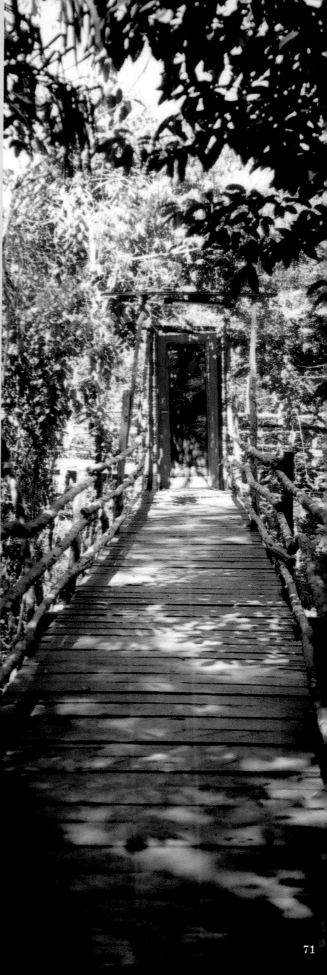

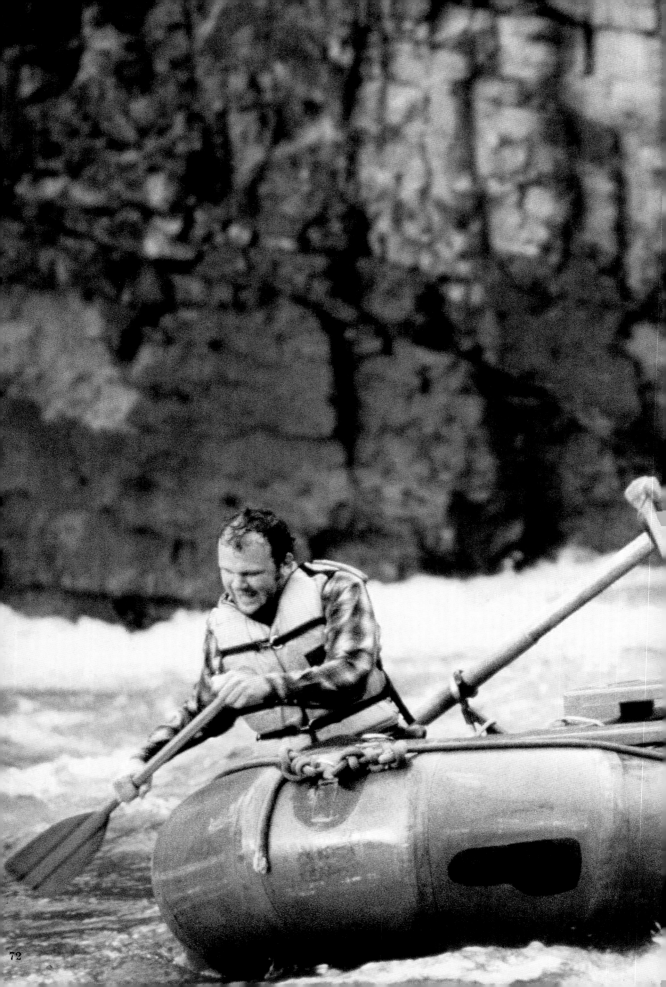

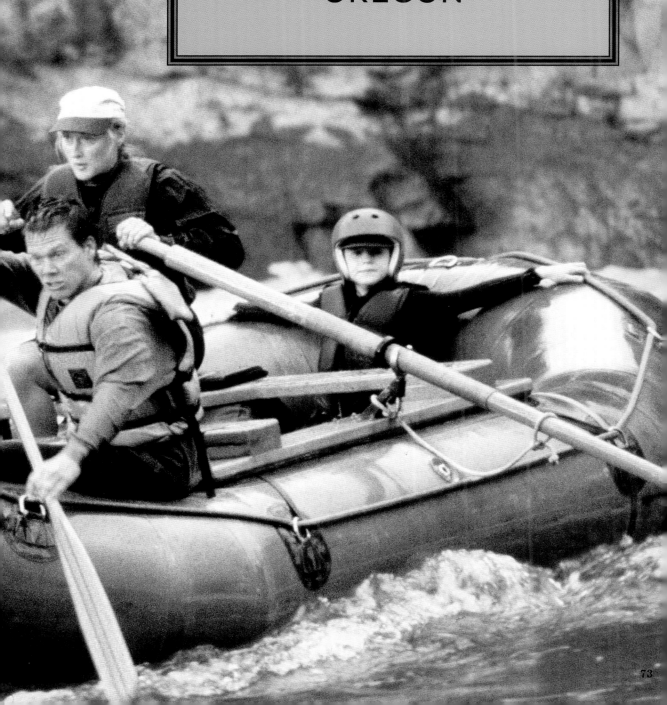

# RAFTING
# THE RAPIDS

## • THE RIVER WILD •
## OREGON

The Rogue River runs peacefully between mountains and fir trees until it reaches the rapids. From there on steep canyons replace the hills, waterfalls follow lakes, and cascading waters attract those keen on salmon fishing and rafting. The location is south of Oregon. A country for bears, miners, and gold diggers.

The Rogue Forest Bed & Breakfast is quietly situated in the heart of the forest, on a small hill not far from the river, which you can hear from the house. The bedrooms are charming, prettily rustic, and surrounded by all sorts of trees and flowers. There are plants just about everywhere, arranged on the graded terraces. The owners, Bev and Marshall Moore, bought the premises three years ago. Bev came from Los Angeles and was a rafting guide in the area. Her grandmother, who tested recipes for *Bon Appétit* magazine gave her a taste for good cooking. Her mother, who ran a small café-restaurant where Bev worked when younger, gave her a sense of hospitality and some great recipes. Bev and Marshall love to welcome guests. They look after you, wake you up in the morning with a great smell of coffee, bring you fresh bread, muffins, and patisseries just hot from the oven, they prepare lunches you can take with you, and provide buffet meals on the large table in the main house. Marshall makes guitars and his workshop is open to all. In addition, the Moores have a thousand ideas to keep their guests busy during the day.

Bears, beavers, otters, ducks, herons, magnificent eagles, bobcats, and even cougars surround the Rogue Forest B&B. You can raft on the Rogue River, which you can see between the branches of the trees. It is not an ordinary river. It is the river into which *Butch Cassidy and the Sundance Kid*, or rather Paul Newman and Robert Redford jumped. It is also the setting for innumerable westerns, and more recently,

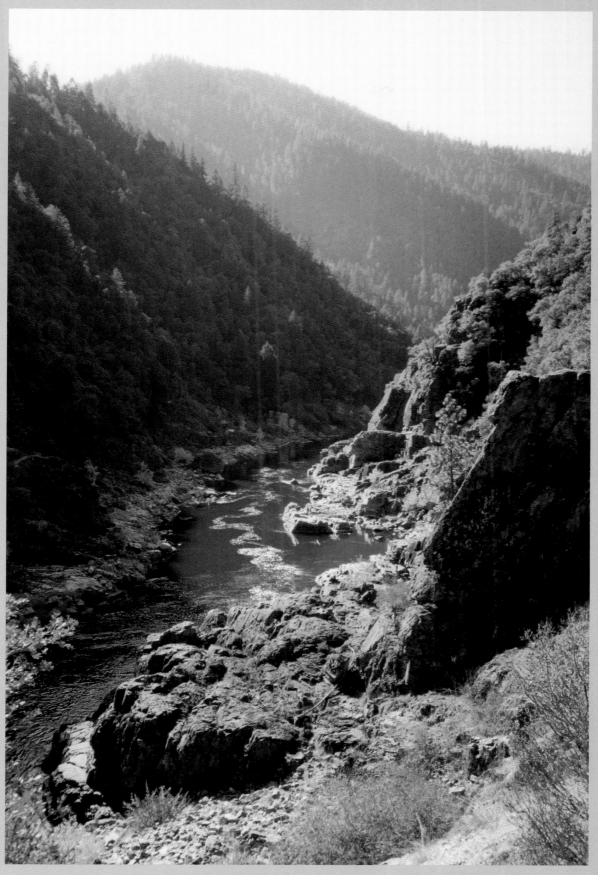

*The rapids and waterfalls that brought gold prospectors to the Rogue River...*

for Curtis Hanson's movie *The River Wild*, Meryl Streep's first action film. Four months on Class V rapids. Class VI being nonnavigable. "I was frightened the whole time," said the actress. "You never knew what was going to happen. You were unable to fight back. You had to stay cool. It was exciting to get out of there....in one piece." The guide, Arlene Burns, who has paddled on all the rivers of the world, introduced Streep to rafting, and was her double in some scenes. "I only had one day's preparation instead of the three that had been scheduled," remembered the actress. I called Curtis to tell him that I did not need any more training. But I had somewhat overestimated myself." What she took for amusing recreation turned out to be much more energetic than she imagined. "But in fact I had fun even when it was frightening. After a completely panicking day, I was ready to start again."

The Rogue River runs from the Cascade Mountains, near Crater Lake National Park, to Grants Pass, and as far as the Pacific Ocean. Legendary and not to be missed for the connoisseurs, the river enchants tourists with its spectacular rapids, waterfalls, and lively waters that suddenly calm down and peacefully

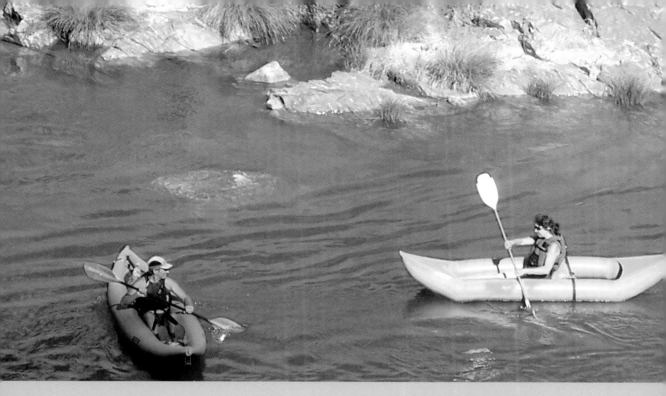

continue their way between the pine trees. Bev Moore left the pollution of L.A. behind for this corner of the United States because she felt like living there for the rest of her life. At the beginning of the nineteenth century, English and American trappers came here searching for furs. Before them, the Indians lived on these shores, where they fished for trout, catfish, sturgeon, and salmon, the pride of the area. The settlers called the river "The Rogue River" because of the fierce resistance from the Indians. The discovery of gold deposits then brought prospectors by the hundreds along the Oregon Trail, in their covered wagons, on the backs of a donkeys, and on horseback; today visitors can still look for the precious metal that comes down from the mountains. Clark Gable, Ginger Rogers, Bing Crosby, Walt Disney, and many others loved the spot. All of them were amazed by the mountains, the prairies, the blue rivers, the lakes, and the impetuous waters. After a day rafting on the rapids, you cannot easily forget either these landscapes or the cries of the guides "Backward!" "Forward!", or the aches and pains, or the fun. You cannot forget the river either. "Here I have found my place on earth," says Bev.

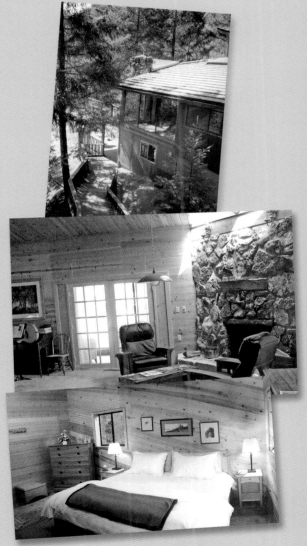

In 1937, Graham Greene arrived in Mexico. Yet another of his eccentricities. Why not? At Oxford, he was already unpredictable; he even played Russian roulette. He loved risk, the unknown, living on the edge, at the limits. He was Communist for a while, became a Catholic for love, and worked for the Foreign Office, and the counterintelligence services. He traveled everywhere, came close to death in Liberia, was a spy in Sierra Leone, went off to Vietnam during the war in Indochina, to Kenya during the Mau Mau rebellion, to Estonia, Latvia, Malaysia, and Cuba. It's an interminable list, insane, but he produced a novel at the end of each journey.

This time it was Mexico, because he had adventure in his blood, because he was fascinated by mysteries and brutal changes of scenery, but also because he wanted to cover the religious persecutions that were ravaging the country. He was not yet the world-famous writer of *Our Man in Havana* or *The Quiet American,* but he already had a preference for heavy atmosphere, countries where the heat is suffocating, where there's degeneration of all shapes and sizes, and where there are complicated stories of lives that topple over. Mexico in 1937 bore no resemblance to anything. Zapata and Pancho Villa had been assassinated but their revolutionary dream continued to set hearts aflame. The presidents, who followed one after another, mixed up all the trends. Anticlericals started a civil war against the Catholics. This lasted for over ten years. Graham Greene spent March and April in the southern part of the country, where repression was the strongest. A difficult and solitary journey inspired him to write what he saw as his best book, *The Power and the Glory*. In it he depicted a disorientated hero, the last priest to escape the persecutions. A poor hunted man, an alcoholic far from pure, who tries to flee but returns unflaggingly. He is finally caught and executed. The book, of which a modest 3,500 copies were printed in England, was a thundering success.

# IN THE HEAT OF THE HACIENDAS

## • GRAHAM GREENE •
### MEXICO

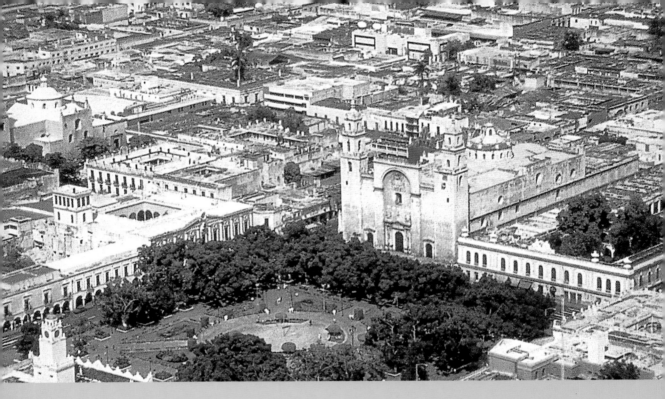

You can just imagine Graham Greene wending his way along the Mexican routes with his hero, along steep pathways, crossing shallow little streams, pastures, clearings, and villages with plazas where "in private houses, grandmothers rocked themselves to and fro in their rocking chairs amidst family photos." Monasteries, tiny little villages, former Catholic colleges converted into hotels, traditional casitas with their thatched roofs, blinding sun, and white dust.... You do not have to look far to discover Greene's Mexico. It is everywhere. Near an ancient church or through the door of an old Spanish house. In the noisy markets, in the narrow roads, in the small plazas where men and women meet in separate groups. The women with their brightly colored dresses, and their splendid ebony hair cascading down to their hips. The men with their beautiful boots and wide-brimmed hats. Sitting on a bench in the middle of the square and watching is a must. The dense crowd, the continous coming and going, the pretty restored shops, the explosion of colors, and the mariachis that all of a sudden come to serenade.

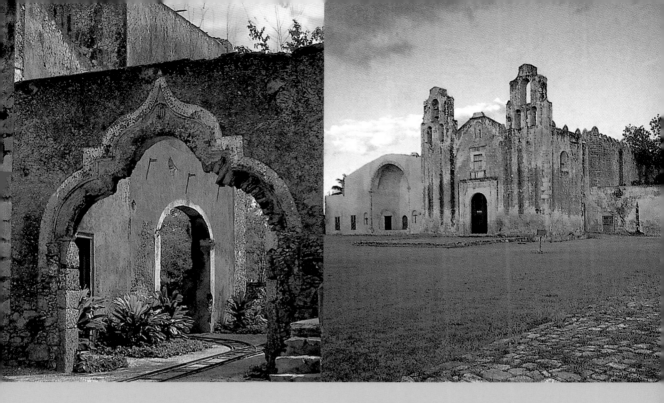

A small, dusty road from Mérida, the capital of Yucatán, leads to Hacienda Temozon. There, in the countryside, nothing has changed. The best thing to do is rent a car and flee the now overcrowded beaches. Then tiny villages appear, plus Mayan ruins, remarkable sites that are World Heritage conservation areas. The hacienda is a former sisal-manufacturing factory. A phenomenal family house with its delightful chapel, and splendid stables transformed into extraordinary bedrooms. Wonderful architecture and poetry, born from its ashes. As are all the estates along Haciendas Road. Once abandoned but recently restored, they belong to another world, and their stories mingle with Mexico's. It's impossible not to be captivated by the splendor of this property, the family treasures laid out just about everywhere, the beautiful old paintings, the heavy luxurious furniture, the luxuriant garden, and the swimming pool—a gigantic band of turquoise water, unrolled as if it has no end.

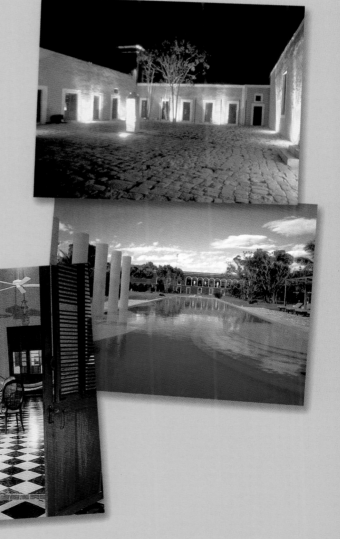

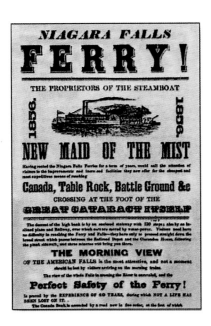

Marilyn Monroe was 27 years old when she shot *Niagara*. It was her twentieth film. Until then, her career could be summarized by charming photos, commercials, and a few minor roles. But Ben Lyon, recruiter for 20th Century Fox, had noticed her in a magazine. She was on the cover of *Life*, had appeared in *Collier's,* and had just posed for a certain calendar that was going to cause a scandal with the first issue of *Playboy*. She was young and fresh, and her screen tests were conclusive. The contract was signed. *Niagara* brought her a long sought after glory. She played the part of Rose Loomis, the disturbed wife of an insane husband whom she decided to have eliminated by her lover in the famous falls. A dark thriller in Technicolor. A lethal woman directed by the master, Henry Hathaway, one of the rare people to have kept a rather good memory of the experience. "She can make any move, any gesture, insufferably suggestive." The film premiere took place in New York in January 1953, was accompanied by many tantalizing posters and even more alluring slogans: "A raging torrent of emotion that even nature can't control," or even, referring to the two "stars" of the film, Marilyn and the falls, as "The two most electrifying sights in the world!"

This was more than fifty years ago, and Niagara Falls was quite a different place than it is today. Of course, the falls looked identical and were in the same location, but none of the skyscrapers, or high-rise buildings that you now see had been built. There was only the Falls Manor Restaurant, Denny's Restaurant, Como, Riverside Inn, and Rainbow Cabins, where the movie was shot. Specially built for the occasion, it became a real motel immediately afterward, announcing proudly: "Marilyn slept here!" This property has since disappeared. There was no Hilton nor Sheraton, nor the shadow of a Ramada Inn. A few celebrities had visited this beauty spot: Charles Dickens in 1842; Mark Twain in 1903; Winston Churchill in 1943; and the future Queen

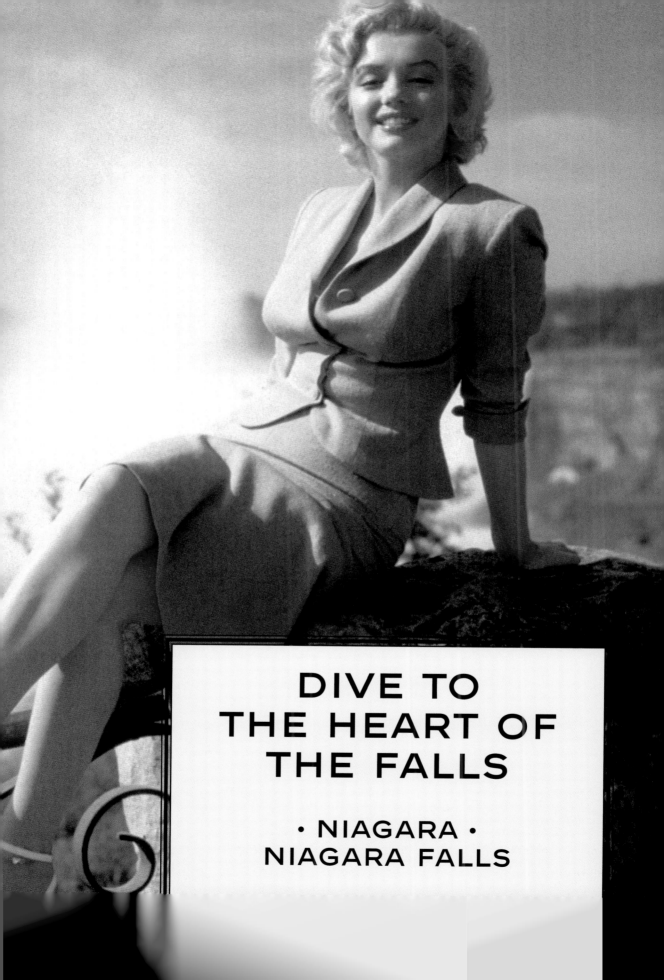

DIVE TO
THE HEART OF
THE FALLS

· NIAGARA ·
NIAGARA FALLS

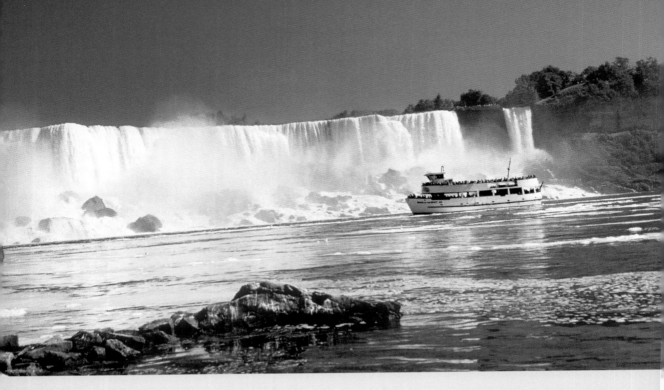

Elizabeth in 1951. Nothing like the stampede this location has since experienced. And as for the bold who wanted to cross the falls... and who managed to come out alive, these could be counted on the fingers of half your hand. In 1901, a schoolmistress, Annie Taylor, asked a few good-natured souls to shut her in a converted barrel. As you can imagine, she was carried away by the rapids and was horribly wounded, but she recovered, and became as famous as she had hoped. Many others attempted the adventure. Most of the teams disintegrated before

even reaching the falls. Or the passengers ended up in hospital. In 1984, Karl Soucek became the first Canadian to survive, and tell his tale.

Today there is no need to shut yourself in a barrel to see the magnificent torrent. You can penetrate the very heart of the basin of the falls aboard the *Maid of the Mist*, which carries visitors wearing oilskins right up to the torrents of water. Touristy, certainly. Wet, very wet, but not to be missed, and stupefying. The platform of the observation deck also provides an ideal viewpoint. How many photos of Marilyn were taken here and

there, in front of, by the side of, in the surrounding area, and opposite the falls? In a red dress. In a black suit. Wearing a red sweater and a black skirt. Wearing yellow oilskins. Hundreds? Thousands? Certainly thousands. On the Canadian shore, where the film was shot, the Sheraton Fallsview is the only hotel to provide a complete and full view of the thundering waters from the bedrooms, the restaurant, the conference room, the meeting room, the club lounge, the terrace... An explosion of panoramic views of all sorts, sizes, and shapes. The building is modern. Floors that reach to the sky. It represents Niagara Falls of today. From there, you can walk to the falls and to the *Maid of the Mist*... Many people come here to get married, and the hotel knows how to maintain traditions. This is thanks to Marilyn, to Niagara Falls, but also, to some extent, to a pretty restaurant that is still there, the Schimschacks, where Marilyn liked to go to be alone with Joe DiMaggio, during the shooting.

Their names are Ella Maillart, Marthe Oulié, Hermine and Yvonne de Saussure, and Mariel Jean-Brunhes. Five frightfully saucy twentysome-thing urchins decide to embark for nine weeks on board the *Bonita*, an old sailing ship without an engine, in 1925. It takes them from Marseilles to Athens, passing by Corsica, Sicily, and the most beautiful Greek islands. Ella Maillart, nicknamed Kini, is the sporty one, the born adventurer, des-tined to become one of the most astonishing travelers of the century. At the age of 22 (not one of the crew members was older than 23!) she has already represented her country, Switzerland, in the sailing event at the Olympic Games. A first for a woman.

During the journey, she was at the helm with a pipe stuck in her mouth, just like an old sea wolf, and, according to Marthe Oulié, who wrote the tale of this joyful voyage, "she only woke up when we called 'Eh! Lieutenant,' a title she was never indifferent to."

Along with Hermine, Ella was the most independent of the lot; eager for freedom, exceptional experiences, and she refused to conform to the acceptable. She wanted a different life and, above all, action: walking, moving about, feeling and grabbing hold of the instantaneous. Her fam-ily was rather more intellectual. However, she said she felt more at ease in action than in thought. Where did this taste for casting off the moor-ings come from? From her Danish mother perhaps? "I only had one ambition in my head: to sail the high seas. So nothing else ever counted in my eyes. Never did I think realistically of living a well-ordered life," she said. Sensible? Settled? Never. Even when she was a 100 years old.

The summer in the Mediterranean breathed freedom, foam, hot bodies, and the exaltation of breaking with their former lives. A journey of inde-terminate duration, to floating ports of call, in more or less precise direc-tions. All of them were overflowing with enthusiasm. All wanted to live an experience. Ella rediscovered Greece, which she had passed through

# VOYAGE IN THE GREEK ISLANDS

## • ELLA MAILLART •
## THE MEDITERRANEAN SEA

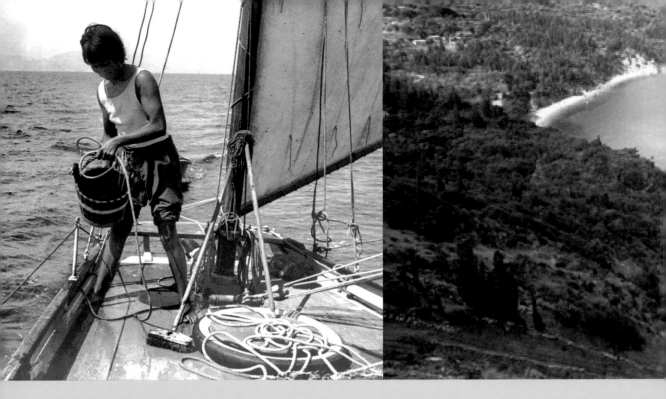

the previous summer. The Ionian Islands, Kefallonia, Ithaca, Lefkada, Zakynthos. And then Dragamesti, Delphi, Corinth, Athens... All ports of call tempted them. The beauty of wild nature. The turbulent preparations for casting off. Picnics on the small islands. The noise of a wet rope that you pull out... The *Bonita* sealed Ella's destiny: travel writer. After that summer, she embarked again, as a sailor, on English yachts. Wrote a book about them: *Vagabonde des Mers (Sea Wanderer)*. But it was firm land that made her what she had always wanted to be. In the Soviet Union, in China with Peter Fleming, in Afghanistan with Annemarie Schwarzenbach, in India in an ashram... All very far away from Greece.

Ithaca, to the west of Athens, is the homeland of Ulysses, sung by Homer in the *Odyssey*. Small and mountainous, composed of rugged cliffs, peaceful creeks, and antique sites, it hides innumerable wonders, such as the Levendis Estate, a magnificent private estate dominating the sea. Its garden shelters four pretty individual villas, which are drowned in a profusion of plants and flowers. Like others before them, the owners had searched for a long time for their dream hotel, finally creating it themselves. The

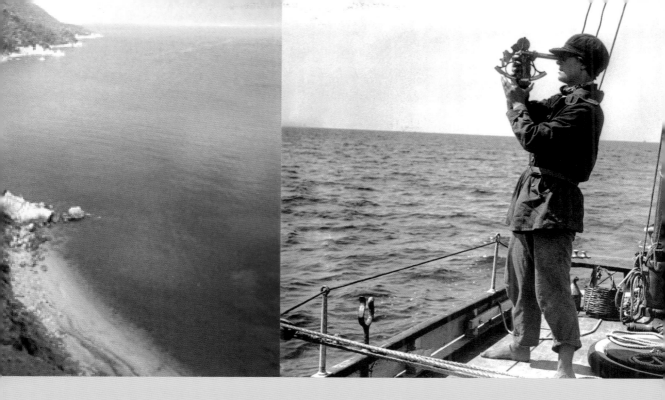

estate is a poem dedicated to nature, with its terraces, gardens, and secret corners overflowing with wild flowers, its magnificent original olive grove, its limpid swimming pool, its hammocks stretched out in the shade, its little paths that lead to the beaches, and the sea just below, always incredibly blue. Levendis Estate produces its own vegetables, fruit, herbs, nuts, jams, herbal infusions, and olive oil; visitors are invited to join the olive harvest. Yoga classes are given there, as well as painting lessons. The family atmosphere is peaceful. Different and intimate, a thousand miles away from mass tourism. Here, you only hear the sound of goat bells, of waves, of the wind blowing; all you have to do is let your-self live, far away from every-thing else—or rent a boat, and discover routes taken by Ella, that wanderer of the high seas.

Let's get this straight: this is an extraordinary experience. Cynics can quibble as much as they like about the Rio Carnival being a gigantic business, but they can do nothing about these four days of madness filled with abundance, beauty, sweat, guts, and a ferocious determination to be happy. It is impossible to remain insensitive to such pure energy and vital strength. To be alive. This is what it is really all about.

Rio deserves these four days. When the most famous samba schools join in, Mocidade, Beija Flor, Imperatriz Leopoldinense, Mangueira, Imperio Serrano, Viaduro, Unidos da Tijuca, Portela, and Salgueiro; when the majestic flag bearers parade along with the decorated floats, the dancers and their *fantasia*—costumes worthy of a Hollywood production; when the *batteria* resounds, the samba, the *cuica*, the percussion, the tambourine, and the big drums (whose brand name has often been registered by the school)…everything else ceases to exist. Nothing can stop the flood of luxury and emotion.

In 1959, *Orfeu Negro* (Marcel Camus) was unanimously awarded the *Palme d'Or* in Cannes. That particular year, *Hiroshima mon Amour* (Alain Resnais), *Les 400 Coups* (François Truffaut), and *Room at the Top* (Jack Clayton) were also shown. *Orfeu Negro* grabbed the award with its legendary story of Orpheus and Eurydice transposed in modern Brazil. The movie mixes actors with professional dancers, amateurs, and the *carioca* population, revealing a Rio hitherto unknown to the public. The *Leme* quarter just a few yards from the beach and the *Morro da Babilonia* just behind, a favela hill covered with jungle,and situated between Copacabana and the Pao de Açucar (Sugar Loaf)... The picture was refined. The poverty was aesthetic. This was better. Suddenly the world saw Brazil, its wonderful Rio, its cariocas, its Carnival, its dancing, its nobility and misery—along with the favelas that had invaded the steep hill slopes.

The music was composed by Luiz Bonfá and the renowned Carlos Jobim. The latter was a brilliant self-taught man, an enchanting carioca, and an eternal poet who one day, in 1962, composed a little tune—on a table

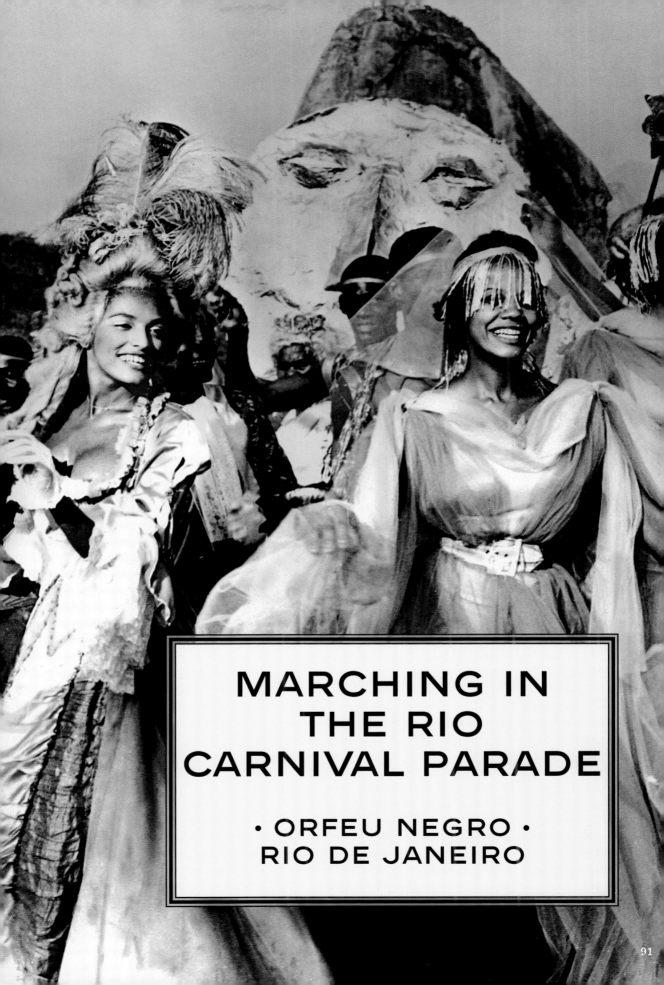

# MARCHING IN THE RIO CARNIVAL PARADE

## • ORFEU NEGRO •
RIO DE JANEIRO

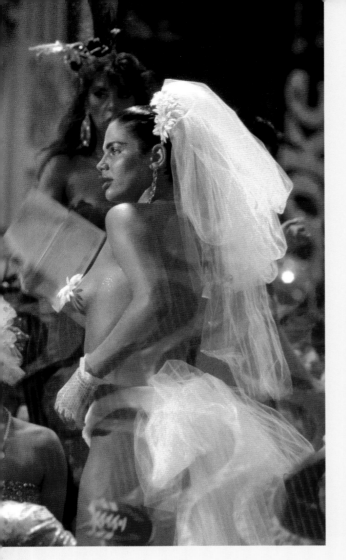

corner in a bar, where he was drinking a *cafezinho* with his friend Vinicius de Moraes. This was "A Garota de Ipanema," which became the most played tune in the world, written in homage to the *belleza carioca,* and to a certain 18 year-old *garota brazileira* who was nonchalantly passing by that day: Heloisa, "*Helo,*" Pinheiro.

*Orfeu Negro* will always remain the movie that enabled the world to discover Brazilian music. American musicians took up the tunes that later became the bossa nova. Stan Getz and Charlie Byrd were unable to resist these exceptional melodies, so full of charm and *joie de vivre.* With the blinding flash of a gunpowder trail, they carried the world away on an enchanting wave, conceived by the *Naçao Brasileira* (Brazilian Nation) in order to survive on this earth.

All you have to do to see the Carnival, and be able to march in a samba school parade, is follow the stream of people. Ask the hotel, learn the lyrics of your school's song—phonetically if you have to—then just let yourself go. At the Marina All Suites they take care of everything. It is the leading boutique hotel in Rio, inconspicuous from the outside and sympathetic just like the cariocas. It is gifted with a fairytale view, a bar that celebrities adore, is and ideally located on one side

of the peaceful Leblon beach, just next door to Ipanema... In the neighboring streets, see the *monoblocos* procession, the road caravans, the gay parade, and the not-to-be-missed *Banda d'Ipanema* (one of the most popular bands of the Carnival). The atmosphere is at its height. You find yourself surrounded by tourists and *brazileiros,* children and parents, rich and poor, young and old—in the streets or along the beaches that Vinicius sang about, which unfold for miles right from the foot of the hotel. The first samba school parade took place in 1932. It set out from the Plaza Onze, which no longer exists. Oscar Niemeyer had not yet created the Sambodrome, a royal avenue (bordered of terraces) designed for the processions of samba, and dedicated to the almost godlike Carnival. Amidst a bewilderment of costumes and floats, tottering under the burden of sequins and feathers, insensitive to either weight or heat, you step in with a wildly beating heart. Some 90,000 spectators bring the house down with their applause, shouting their songs, dancing on the terraces; flooding the universe with dreams, and unpolluted life. You hold your breath. And then you leap in... Extraordinary, just as I said before.

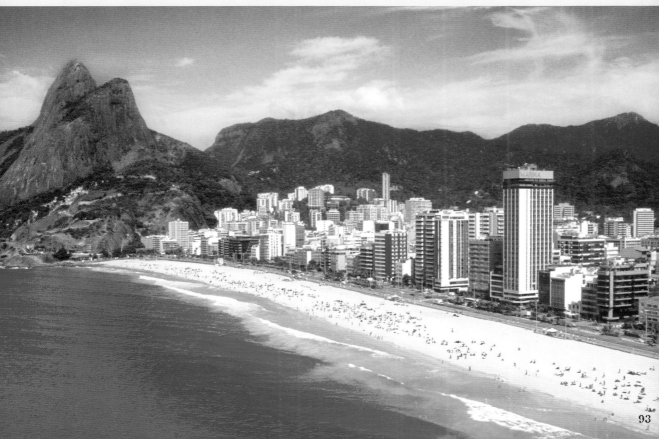

# CLIMBING TO THE TOP OF THE WORLD

## · SIR EDMUND HILLARY ·
## NEPAL

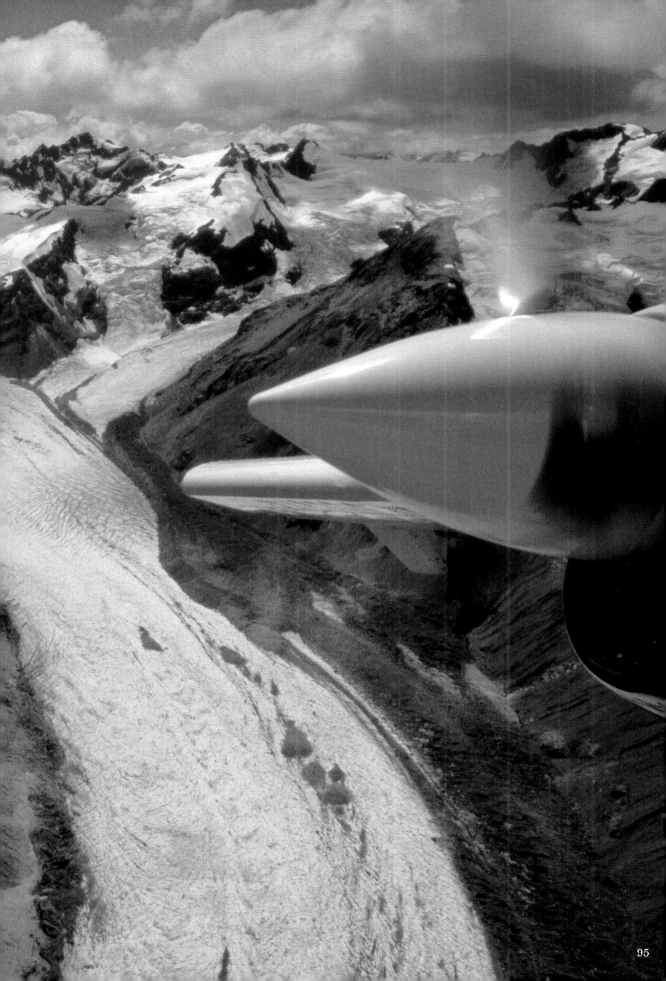

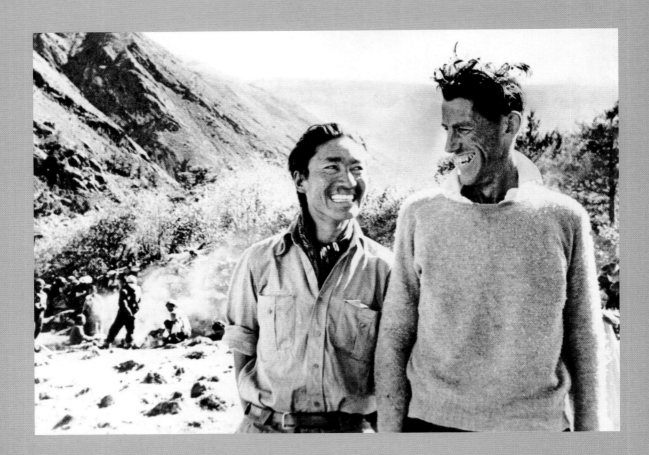

Who hasn't dreamed of Kathmandu? Which writer, painter, artist, adventurer, traveler or voyager has not once imagined the narrow streets, the dust, the noise, the squares encumbered with temples, and the highest mountains in the world? We should make a habit of dreaming. When you enter Dwarika's Hotel, the preliminary sketch you imagined reveals itself as a picture, with all the features you might have thought of. This hotel really is a blessing. A journey in its own right. A hotel-museum whose décor required hours of dedicated work. Sculpted columns, polychromatic wood, bronze statues, sixteenth-century windows, intricately wrought doors, significant collections, traditional materials, and handmade bricks. Dwarika Das Shrestha, the designer of this intoxicating journey, wanted to save everything of his country that could be saved. The sadness he felt one day when contemplating invaluable devastated ruins led him to attempt the impossible. He set up an art school, and a research laboratory for techniques that had disappeared. He rehabilitated ancient craftmanship, successfully combining contemporary designs with the traditional, and assembled in his hotel some of the most beautiful pieces of Nepal's Newari architecture, the works of

the inhabitants of the Kathmandu Valley from the thirteenth to the seventeenth century, achieving a fascinating collection of harmony, luxury, and beauty. Dwarika's attracts the whole world whether they be dreamers, people passionate about ancient art, or exhausted trekkers who come to Kathmandu to tackle the "Roof of the World."

Sir Edmund Hillary, then an unknown beekeeper, set out from Kathmandu in 1953. From New Zealand, he was a beanpole, six feet two inches tall, and rather discreet with a craggy face. His experience with mountains was limited but he had already accompanied his

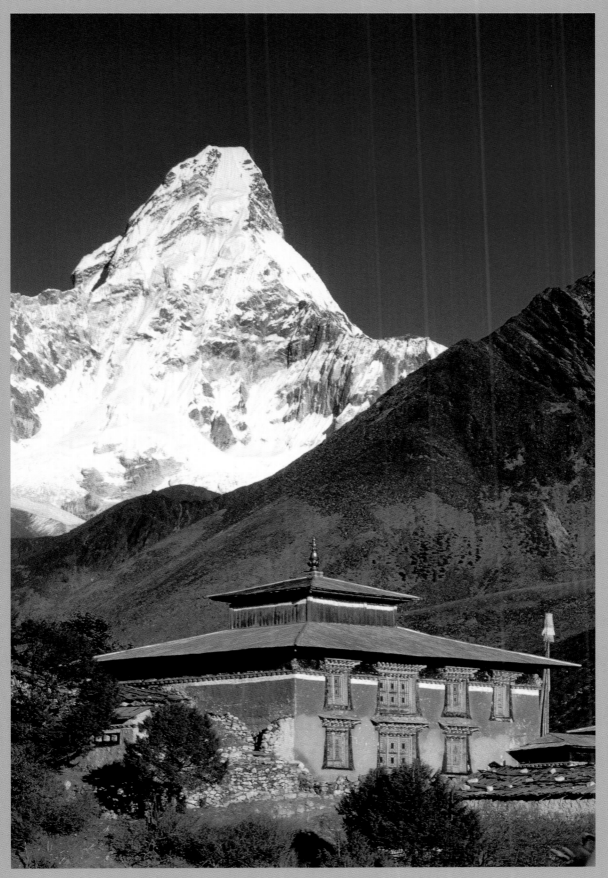

*Kathmandu, fascinating landscapes full of harmony...*

hero, Eric Shipton, one of the greatest alpinists of the twentieth century, on a reconnaissance expedition, one that became a sensation among alpinists.

The energy and the determination of the young man earned Hillary a part in another new expedition. This time, the idea was to conquer the mountain. The highest mountain on earth: 29,035 feet high, nearly twice the height of Mont Blanc. The team included 15 climbers, 450 porters, and 34 Sherpas. This was in May 1953. The first stage led them to Kathmandu, then to the Thyangboche monastery, some 186 miles away. The leader of the expedition appointed Hillary and a slight Sherpa from Nepal, Tenzing Norgay, as the second assault team. At dawn on May 29, after a night spent at 28,000 feet, the famous roped party loaded onto their shoulders the 31 pounds of oxygen apparatus and set off over the soft snow. Hillary was carrying a rucksack on his back that weighed 66 pounds. They were dressed as cosmonauts, loaded like mules. Progress was slow. The cold, dreadful. "The slightest movement on these ledges could but lead us to disaster," said Hillary. It looked impossible

to achieve. Nevertheless, five hours later, they were the first to reach the peak. Hillary simply commented "We've got him, the bastard!" Despite all their efforts, they only spent a quarter of an hour up there. "We shook hands. Tenzing threw his arm around my shoulders, and we patted each other on the back before we became completely breathless"... Tenzing Norgay then slowly unfolded four flags: the United Nations', the Union Jack, the Nepalese, and the Indian flags. Hillary calmly took photos. These were published in the July 1954 issue of the *National Geographic* magazine. The title: "Triumph on Everest." Over sixty pages of a dream, with photos that were published all over the world...

Recently interviewed in his home by a French journalist, Sir Edmund Hillary asked to be called "Ed." No special effects... No affectation. Moreover, he talked more about the Himalayan Trust that he created to help the Sherpa people of Nepal than about the extraordinary day on Mount Everest. A short while ago, his son Peter stayed at Dwarika's on his return from a trek in the area. They remember him at the hotel. Peter said it was fantastic to get back and find a hotel with running hot water and nice deep bathtubs.

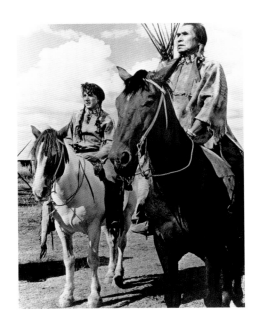

For thousands of years, the Canadian region of Alberta, in the Rockies, was the homeland of the Cree and Blackfoot Indians. They followed the migrations of buffalo, which were essential to survival. They hunted for their meat, used bones to make tools, their skin to create clothing, their horns for spoons, their tendons as bow strings or sewing thread, and their skulls as religious symbols at ceremonies. There were many buffalo then, running all over the plains into the infinite horizons. Then came the pioneers, hunters, trappers, and white settlers with their cattle. With the arrival of the railroads, hunting buffalo from wagons began... Nearly all the large herds were decimated. The Indians lost their main resource, and their pride.

In 1970, Arthur Penn shot a movie—*Little Big Man,* adapted from the novel by Thomas Berger—with Dustin Hoffmann playing the part of the 120-year-old man who was adopted by the Indians and who is the only white man to have survived the battle of Little Big Horn capable of recounting what he has lived through. Arthur Penn shot the movie in Hollywood, in Montana, and in Alberta (approximately thirty-seven miles from Calgary, in the Rocky Mountains). He had about fifty tepees and Indian tents put up in the bend of a river so as to portray scenes from the daily life of an Indian village and, ultimately, the Washita River massacre, during which General Custer decimated a whole Cheyenne community. Arthur Penn thought he would find snow in Canada. However, snow did not fall. He nevertheless decided to shoot the last scene of the film, the one in which the Indian Chief Old Lodge Skins gets ready to die under the blazing sun, feeling not only his own life leaving him but also his people's traditions. Penn was lucky: that night, snow fell and the next day the landscape was completely transformed.

*Little Big Man* is a masterpiece of visual poetry. So is the Paintbox Lodge. Both pay homage to the glorious times, at the beginning of the century,

# CANOEING WITH THE INDIANS

## • LITTLE BIG MAN •
## ALBERTA

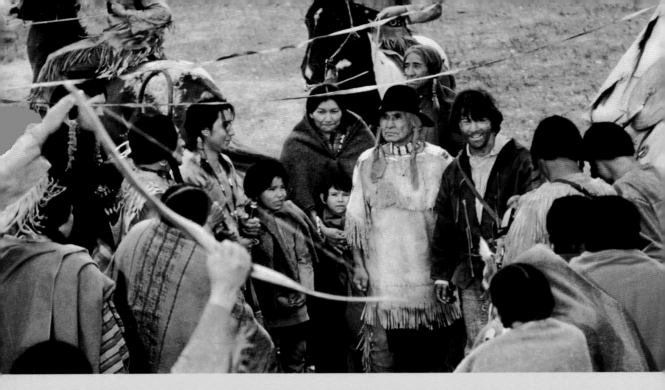

when those who came to the Rocky Mountains were seeking an ideal rustic world. It was at this time that the famous Calgary Stampede, the most famous rodeo in Canada, was invented. Paintbox Lodge reminds of this cowboy life that attracted the first explorers so much. Completely restored with extreme care, the hotel and its charming house, Creek House, have become a cozy and luxurious sanctuary, thanks to the work of Gail and Greg Elford, a talented interior designer and a master carpenter, respectively.

Everything there conjures up the region's history: the beautiful chimney surmounted by a magnificent Indian face, the ancient objects, the beautiful colored blankets placed just about everywhere. The atmosphere is elegant, warm, and comfortable. A few miles away, the stunning virgin beauty of the Canadian Rockies, a UNESCO World Heritage conservation area, unfolds. Stretches of land that are extraordinarily empty whip your blood, buck you up, and fill your lungs with incredibly pure air. A feeling shared by

keen travelers who ride over on horseback, in a dogsled, by canoe or kayak, covering the same land as that trodden by the Cree and Blackfoot Indians. Today's traveler may not be the first to arrive, but the impression of discovering a new world remains. Translucent green lakes, immense fir forests, summits, glaciers—the incredible and interminable wide open spaces of one of the largest countries in the world... Time has not changed the landscape, nor made us forget history. Yet another anecdote. In the movie, the part of the old Cheyenne chieftain was played by Chief Dan George, 71 years old at the time, who was the son of a tribe chief. George was born in 1899 on a Vancouver reservation, he started his motion picture career at the age of 60, without ever having had any acting training. His unexpected fame made him a spokesman for his people, a role that he proudly held until his death in 1981, on the same reservation where he was born.

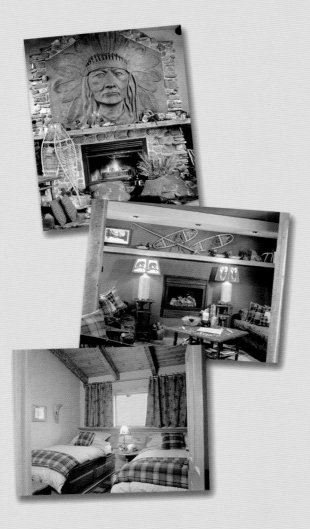

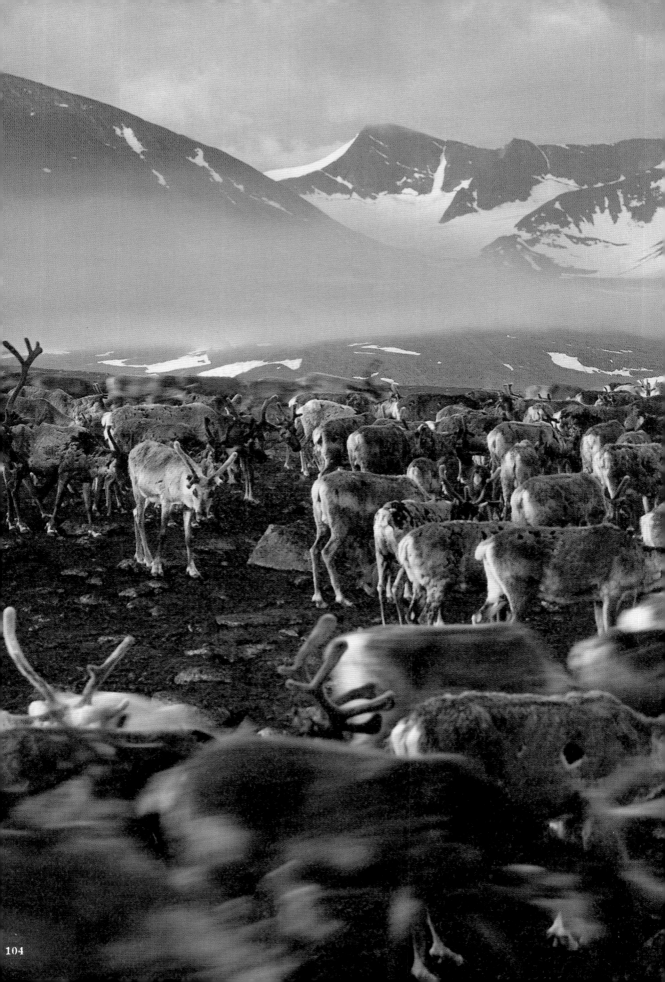

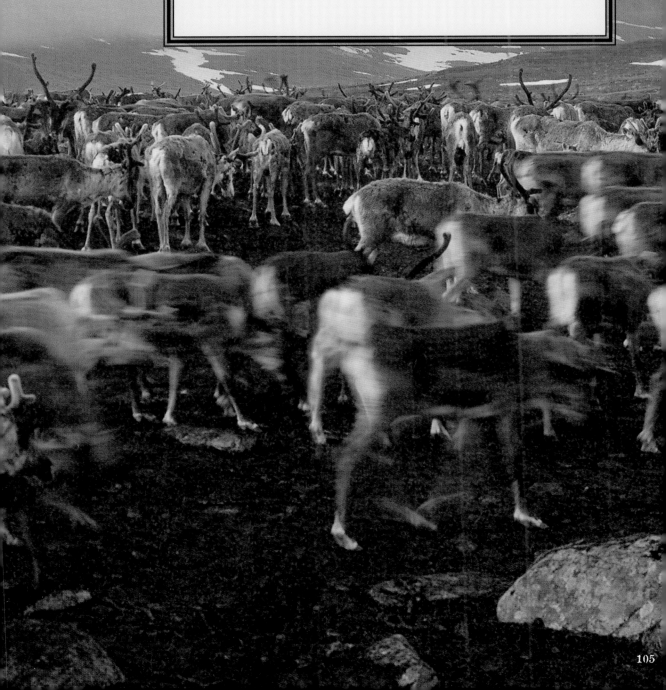

# LIVING IN AN IGLOO

## • ROBERT E. PEARY •
### THE NORTH POLE

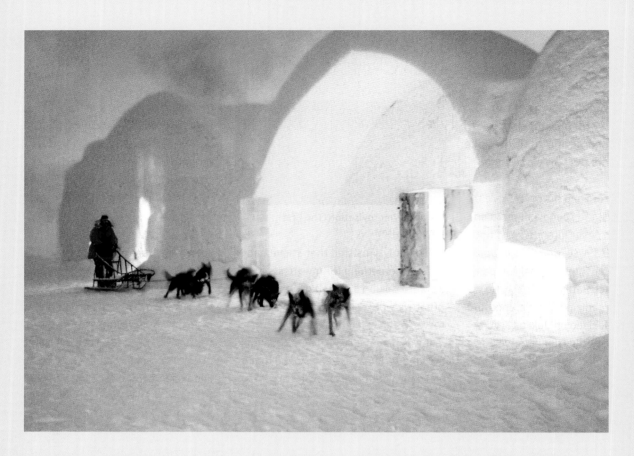

The Ice Hotel is not a hotel. It is quite something else. It is an igloo village. An ice palace. A frozen museum that escapes anyone's conception of a hotel. Located in Sweden, 124 miles from the Arctic Circle, in the town of Jukkasjarvi, it started to welcome a handful of tourists in 1970. The owners built an art gallery with ice. Guests wanted to spend the night, and the Ice Hotel was born.

The place is a dream, an enchantment, bewitching with its sixty bedrooms that are not really bedrooms, windows, tables, chairs, columns, lamps, and whole lounges sculpted in ice, which are different every year, depending on the inspiration of artists who commence working in November, for guests who start to arrive the following month. There is a reception hall with a sumptuous ice crystal center light, an Absolut bar with glasses made of ice, an ice chapel for those who wish to be married, an ice theater where Shakespeare is performed in Lap, and an orchestra with ice instruments that transmit real sounds. All this melts under the first rays of the April sun, then goes on to swell the river Torne pending reconstruction the following year.

On arrival, you put your things in one of the lockers in the nearby wooden house, where you are loaned an isotherm combination, a fur bonnet, gloves and boots adapted to the temperature, which varies between 16°F and 24°F in the igloo. During the daytime, the place is open to those who want to visit it. In the evening, those who spend the night there draw a little curtain in their bedroom, and disappear under the thermal sleeping bags laid out on ice beds covered with reindeer skins. Sleeping in an igloo with only the cold and the bluish mist around… It is barely believable. And in the morning, someone comes to wake you up with a hot cranberry juice and a big smile.

It is impossible not to remember that less than a century ago, this sort of sight was reserved to a few frightfully keen travelers. When the American Robert

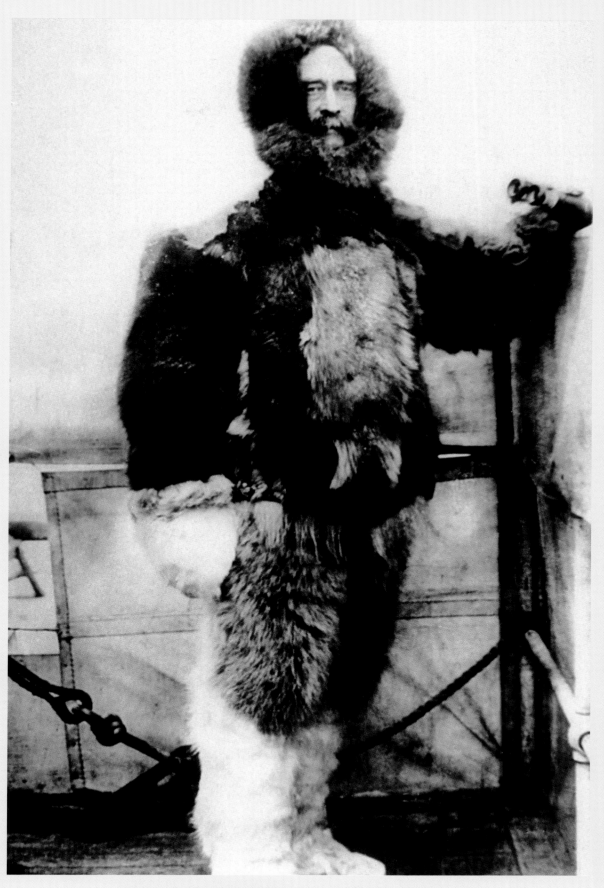

*Robert E. Peary, the first to reach the North Pole.*

Peary decided to explore the North Pole in 1909, it was impossible to count the number of those who had already died attempting this feat. However, Peary had two trump cards: he knew the poles and he prepared himself with a near military rigor. He had lived in Greenland with his wife, Josephine, the first female Arctic explorer. He was familiar with Eskimo methods, which, in his opinion, were the best suited for the goal he had set. With his companion, Matthew Henson, Peary attempted, at the age of 53, a last chance trek. He wanted to be the first, and to become famous, whatever the cost. The National Geographic Society, which had just been established, and financed expeditions all over the world, asked him to plant the American flag at the furthest possible northern point.

He set off with 24 companions, 15 sledges, and 133 dogs, but continued with only 4 men, 5 sledges, and 40 dogs. By boat at first, then by dogsled. The temperature was around -76°F. Peary, whose toes had been frozen during another expedition, let Hanson take the lead with the dogs. It took five months for them to reach a spot from which they could finally send the long-awaited telegram: "Stars and stripes nailed to the North Pole." They ignored the fact that five days earlier, a certain Frederick Cook had sent a similar telegram.

The matter still remains to be decided. Whatever. Who cares? The North Pole remains a myth. It is the sort of place that you dream of seeing one day in your life. Peary and Hanson covered miles over the ice,

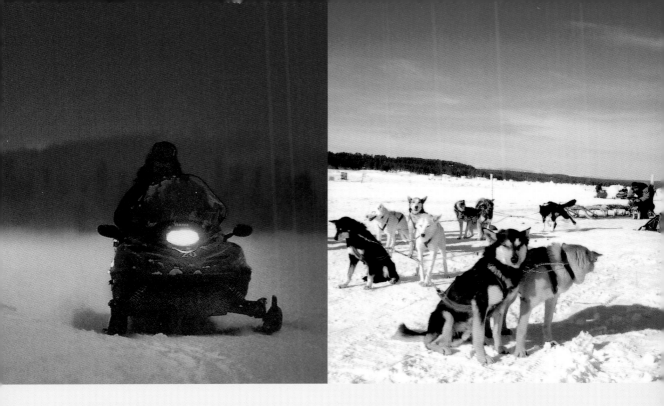

drawn by dog sledges. The same sledges that now carry us over the frozen lakes, if we do not wish to traverse powder snow on snow bikes. From the very first minute there are a myriad of memories: high-speed days across snow-filled plains; the pale green glimmering of the northern lights; and the knowing and joyful glances from the other guests, who are amazed as well. The March and April sun that illuminates this magic, from the early morning on, makes you regret instantly that it is all ephemeral.

# A COWBOY'S LIFE

## · JOHN WAYNE ·
### COLORADO

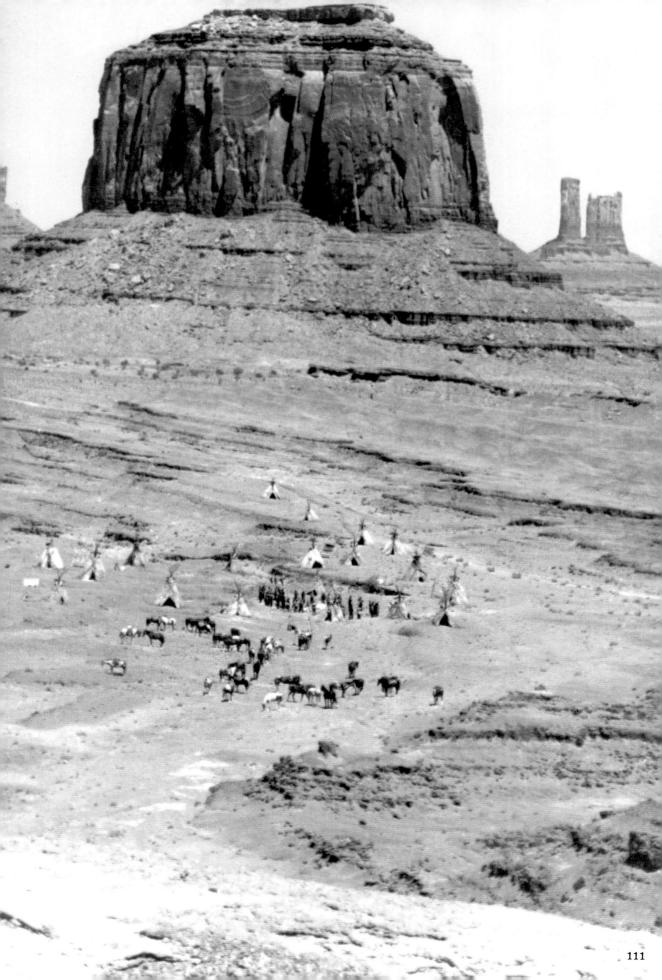

1861. The Pony Express transported the mail from St. Louis to Sacramento for the first time in the record time of ten days. Buffalo Bill, Davy Crockett, Daniel Boone, and Kit Carson were ready to enter history. Colorado was suddenly covered with wagons of pioneers passing over its trails and tracks—pioneers who wrote one of the most fascinating stories in the United States, and cowboys accompanying their herds. At that time, they needed several months to move the cattle in the midst of dust, heat, and flies. The work was dangerous and badly paid. Up at dawn, the cowboys had to slip among the herd, fearing thieves, Indians, drought, tempests, and floods. Once again hitting the trail as soon as daylight appeared. The rest of the year, they devoted to marking and caring for cattle on the ranch, collecting all the animals dispersed in the pastures, mending fences, and covering the same infinite countryside, from morning to evening, always on a saddle.

Cowboys built the legend of the West. So did John Wayne, a giant from Iowa, who enabled the world to discover America in the motion pictures of John Ford, Howard Hawks, Raoul Walsh, Henry Hathaway, Michael Curtis, and many others. In truth, the real hero of such movies is the scenery. The journey of the leading character is what really counts, and the audience shares the view he sees during his travels—the way of life in towns that have just been built, on new territories, in ranches of a thousand hectares. There are armfuls of films that

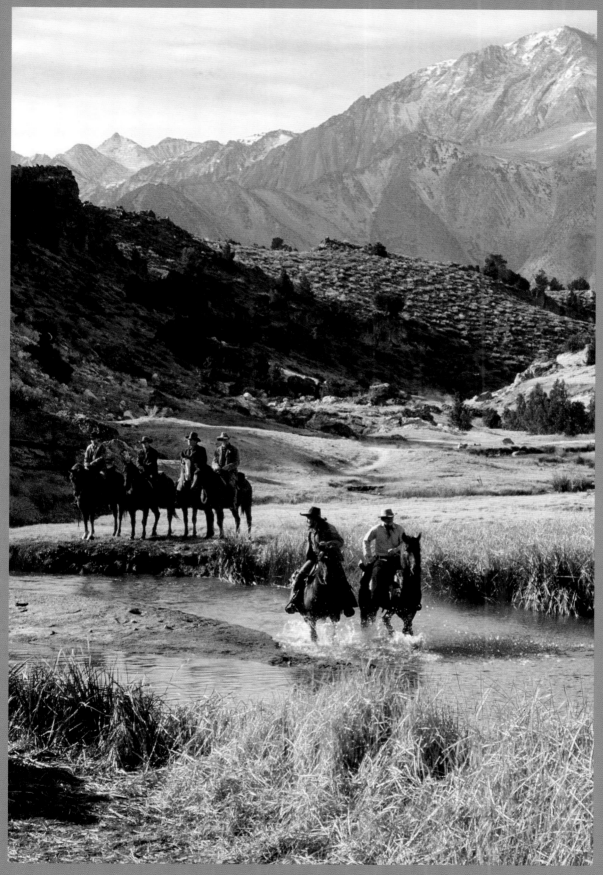

*In 1969, Henry Hathaway directed John Wayne in* True Grit.

give more details about the geography of a region, and more information about its inhabitants, than any history book.

For decades, John Wayne was the only possible cowboy, living out the fate of the pioneers at full gallop. In 1956, he shot *The Searchers* with John Ford. The film is legendary. The collaboration between the two men even more so. One discovers Monument Valley of course, but also splendid Colorado, its mountains, its valleys, Gunnison—a western-style town from the beginning of the nineteenth century, transformed into a military base for the movie—Aspen, the trading posts, and the Indian tribes of the plains—the Apaches, the Cheyennes, the Comanches, and the Kiowas… Colorado once again in 1962 (Durango and the Uncompahgre National Forest) in *How the West was Won*, directed by John Ford, Henry Hathaway, and George Marshall, with Henry Fonda, Gregory Peck, James Stewart, and Richard Widmark. The pride of western movies. Colorado, again, in 1969, in *True Grit*, directed by Henry Hathaway. Shot in Castle Rock, Montrose, Ouray, Gunnison again, Ridgeway—

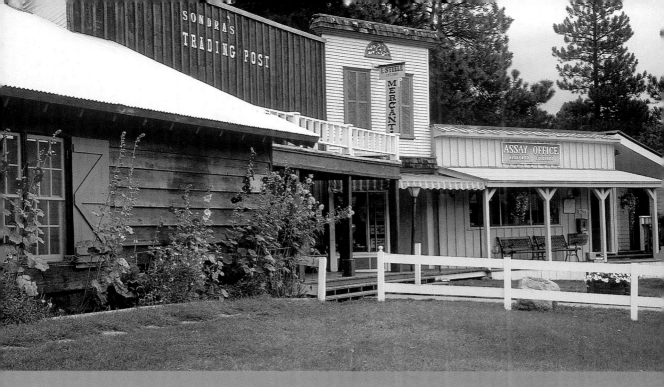

the town that became Fort Smith in the film—and the Adams ranch, in the shade of the San Juan Mountains. *The Cowboys* (1972; directed by Mark Rydell) shot near Pagosa Springs on the San Juan River, tells the story of a rancher who, abandoned by his cowmen, hires an inexperienced group to help him lead a herd across the prairie. Always the Wild West, the immense prairies, the ranches, and the dust… For more than a century, the Dude Ranchers' Association has kept together all the ranches that want to preserve this typically American atmosphere. One, the Colorado Trails Ranch in Durango, in the splendid San Juan Mountains, has a friendly atmosphere, a homey life in the country, and friends who gather around a barbecue after long days on horseback… Rustic cottages open out onto the daz-zling valley. Guests can help move cattle or shoe horses; they spend evenings gathered around a camp fire to the rhythms of traditional country and western songs; they go for wonderful rides in the forest and in the beautiful mountains; they watch rodeos if it is the season, and they try out country and western dancing in the Opera House. There is also trout fishing, archery, clay-pigeon shooting, rafting, and picnics in the fantastic Mesa Verde Park—enough to fuel extensive conversations at supper in the beautiful and undeniably western-styled dining room.

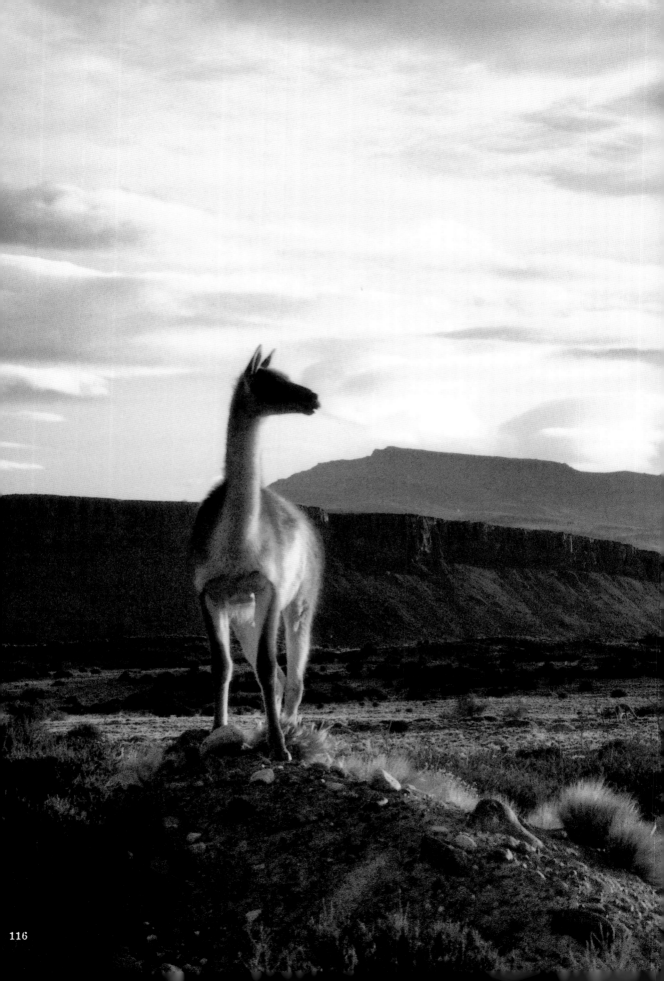

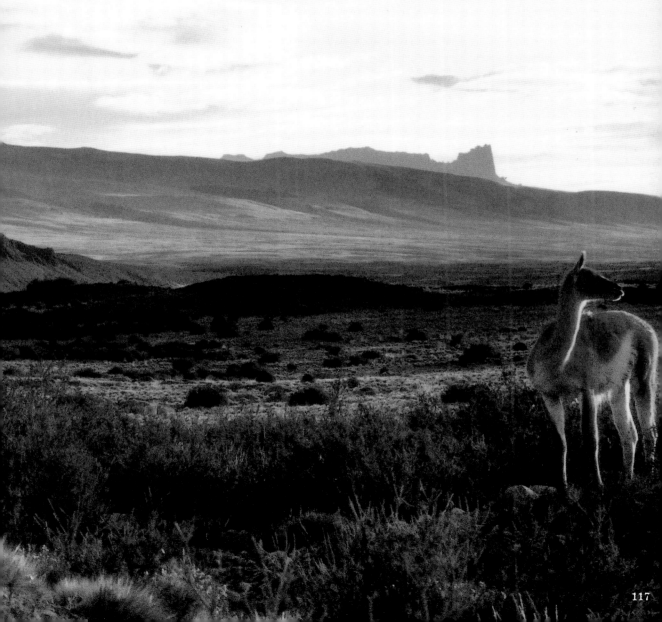

# OFF TO MEET THE GAUCHOS

## · FRANCISCO COLOANE ·
### PATAGONIA

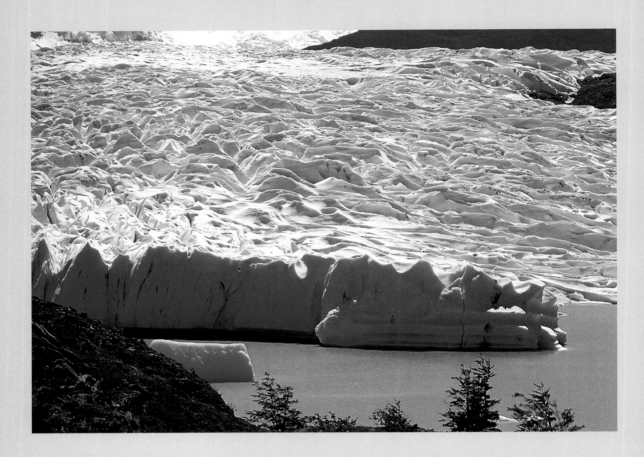

The Explora Hotel… Chilean Patagonia… Miles and miles of desolate land at the end—really at the end—of the world. Another planet, some say. They are not wrong. Here, nothing resembles anything. There is no softness to facilitate the approach, no polished decor, no restaurants on every street corner, no luxury visible to the bare eye to soothe visitors. Nothing obvious, nothing accessible. You have to work hard and slave away like the men and beasts who live here if you want to catch a little of this strange poetry. Because the Patagonian world is a puzzle, interwoven with emotions, fantasy, solitude, brutality, ferocious joys, and lives tied to the power of the place. The hotel is only one unusual creation among others; in fact, it is the spirit of the place that is all-encompassing.

Francisco Coloane was made for this part of the world. At the age of twenty, his life was turned upside down by one of his uncles. "He was always bugging me with his Patagonia. 'Where is it?' I asked him. He just stretched out his arm toward a fringe of magnificent pink sky… When I got there, I felt as if I was paralyzed. Twenty leagues of arid land bordering the Atlantic coast of the Tierra del Fuego. You might call it the birth or the boundary of an unknown planet… Few people triumph over the trial. Most people last under a year… The currents suddenly change direction. Compasses go berserk and even the best sailors get lost."

Fantasies. Emotions. Journeys above the stars. The novels written by this tousled adventurer are full of gauchos playing with death, mad sailors, animals that are unknown anywhere else, peones working furiously in the *estancias*, and idealists looking for a new life. The young Coloane set off for Punta Arenas, the capital of Patagonia, where he became a horseback-riding shepherd in an *estancia* of 70,000 sheep. Just himself and nature. *Nada mas*. "You felt and knew that you were really alone."

*Francisco Coloane and the journey to the end of the earth...*

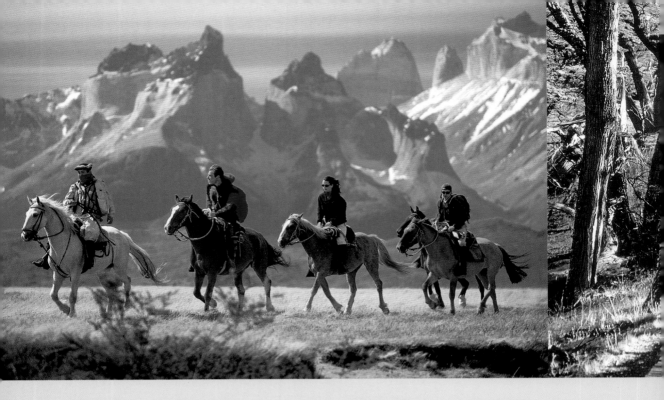

His father, a whaling captain, had transmitted the love of legends and myths to him as well as the love of hard lands that move you effortlessly, because everything that lives appears to be a miracle. These memories never left Coloane. To this, he added his Chilean mischieveness, and wild characters, haunted, sometimes even truculent. Patagonia is his homeland: "It is a place where you are filled with wonder at each moment."

The influence of the place comes from the insane winds, the twisted branches of trees that always look as if they are about to break, the inspirational fjords, the herds of guanacos as elegant as ballet dancers, and the incomparable light that is pink, gray, mauve, and bronze. A completely infinite range of unbelievable features that disturb you and force you to see the world in a different light, before winning you over. For centuries, nobody ever thought of going there on

holiday. Tourists have no place here; travelers have only recently. The Explora Hotel is far, very far from what the majority of people have experienced. First you have to fly for four hours from Santiago, then travel five hours overland from Punta Arenas, and with only a short stop on the way, you get there. It is fine. You have time to digest the view, to put it on your level, to become attached to it. You also have time to realize where you are: in the middle of the Torres del Paine National Park, somewhere between the Tropic of Capricorn and the Arctic Circle. It is one of those rare places in the world that disorientates you and makes you question why you are there. The Explora does not give answers. It swathes you in its soft, cozy cocoon and eradicates all your habits in one go. It takes you on fabulous cavalcades with maté drinking gauchos, and with guides who have Patagonia "nailed to their hearts." Patagonia offers sunrises that hit you in the stomach, forcing you to walk in the snow when it is hot on the other side of the world or in the burning sun when it is snowing elsewhere. It's a fabulous place where you will dis cover glaciers that shine just like giant diamonds; incongruous creatures; and also men who do not talk much—and who remind you of the heroes found in the books of London, Conrad, and Melville.

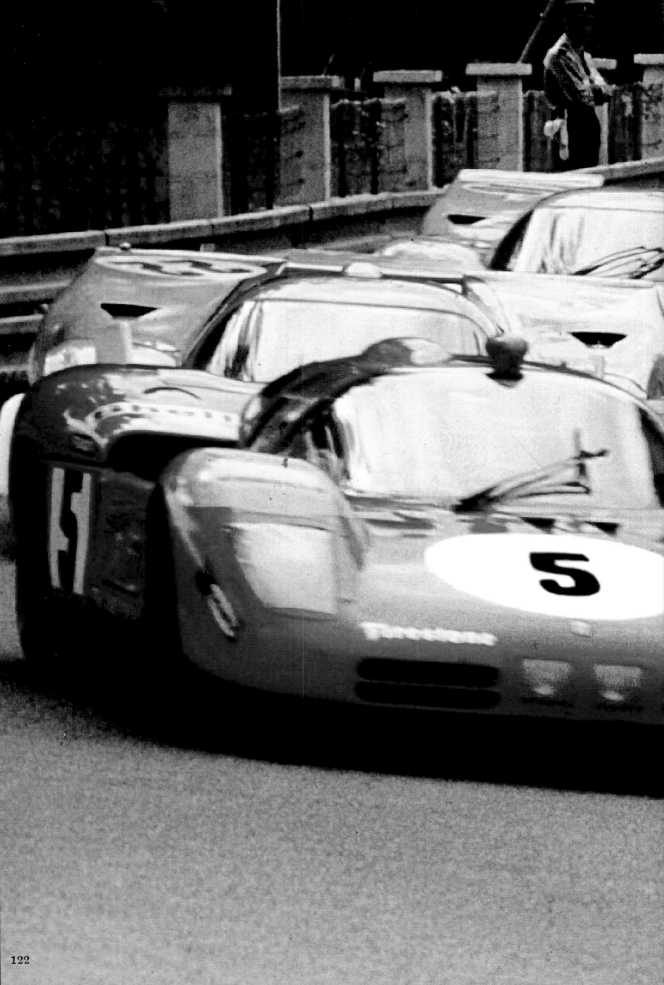

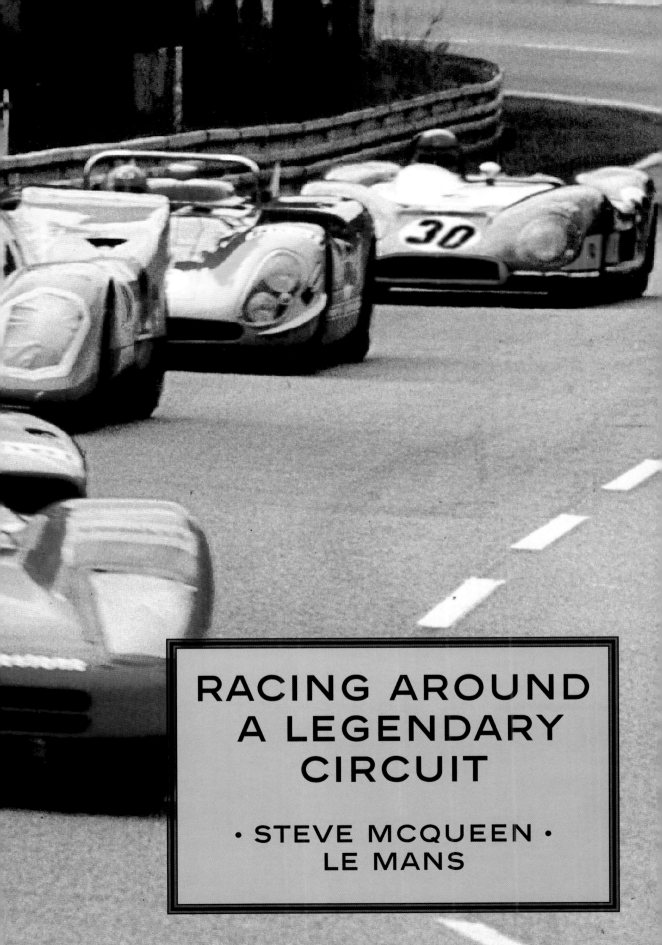

## RACING AROUND A LEGENDARY CIRCUIT

### • STEVE MCQUEEN • LE MANS

The end of the 1960s, and the beginning of the 1970s was a blessed era of the automobile dream. Not many live images. A legendary 8,451-mile lap. Brands of car that are now mythical. Only the privileged few were lucky enough to experience the extraordinary atmosphere that makes one fantasize; with duels at the wheel between Porsche 908s and Ferrari 512s; Alfa Romeo 33/3s and Matras MS 65; Lolas T 70 and Chevrons B 16; The drivers included Andretti, Amon, Regazzoni, Hill, Ickx, Stewart, Beltoise, Donohue, Pescarolo, Bell, Peterson… They were of all nationalities, from different backgrounds. Jean-Pierre Beltoise was the son of a Paris butcher. Chris Amon was the son of a New Zealand farmer. The Andretti family had fled Communist Istria for the United States. The Englishman Graham Hill had never driven a car before the age of 24 due to lack of money. Stewart's family ran a garage in Scotland.

Donohue, Peterson, and Hill met their end there… Beltoise injured his left arm. Stewart nearly lost his brother, also a racing driver. In 1969, Pescarolo did a heroic race in his Matra, by night, in the rain, without any windshield wipers. The same year, Jacky Ickx crossed the track, on foot, to protest against the "Le

Mans" type start (consisting of running to one's car), which he considered too dangerous. Nevertheless, he won that year after three hours of wheel-to-wheel battle with a Porsche. In 1971, Steve McQueen gave the start.

For a long time McQueen had wanted to make a movie about Le Mans. Everyone knew he loved speed. He demonstrated this in *Bullitt*, behind the wheel of his Mustang 390. This time he wanted to drive in the race, and had prepared himself by participating to the twelve-hour race in Sebring. Although he finished second, that was not enough to convince the insurers, who asked that the race be re-created. Then, live footage from the 1970 race would be

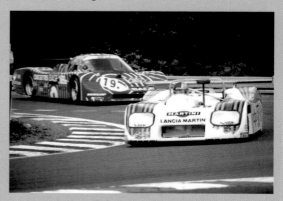

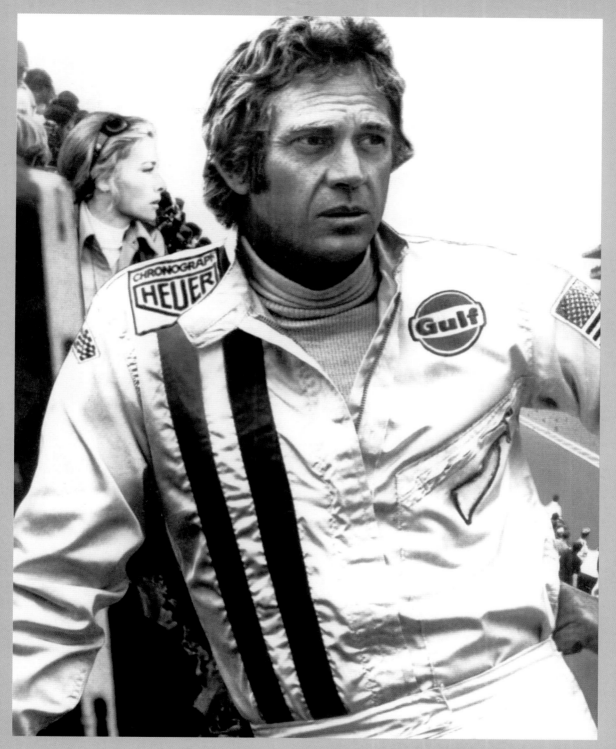

*Steve McQueen on the making of* Le Mans.

added. Frustrating. Nevertheless, McQueen had the firm intention of having fun in any event. Having fun… He just missed death by avoiding a truck going 186 miles per hour. Too much cocaine, too much acid, people said. The production rented and purchased twenty-five racing cars, reserved the circuit for three months, installed cameras onboard a Porsche 908—incredible at the time—called upon professional drivers, such as the Brit Derek Bell, then 29, who lived with the actor for six weeks. They got on very well because Steve knew that Derek did not want to become an actor. McQueen just loved the

atmosphere of the race. He knew that he had no chance of becoming a great racer at the age of 40, and according to Derek, he did quite well. He just wanted to race and be with them. *Le Mans* is a semi-documentary, just as McQueen wanted it to be, with a touch of sentiment to please the producers. The shooting was another endurance race. Derek's Ferrari caught fire and his face and hands were burned. The driver David Piper lost his right leg when he crashed into a Porsche. Steve McQueen never stopped arguing with the co-producers, spending most of his time in his private caravan, going up and down the circuit…on a typically French *vélo-solex* motorbike he'd discovered in a shop. He found nothing better to do than suddenly take off for a vacation in Morocco. McQueen emerged from the experience ruined, worn out, in full midlife crisis. His marriage did not survive. However, he had made his movie. A movie about racing, yes, but also a movie about the end of the Golden Age of the sixties.

During the year, when the race is not taking place, it is possible to drive around part of the twenty-four-hour circuit, on the National Road 138, at Mulsanne. The Concorde Hotel, the only four-star hotel in

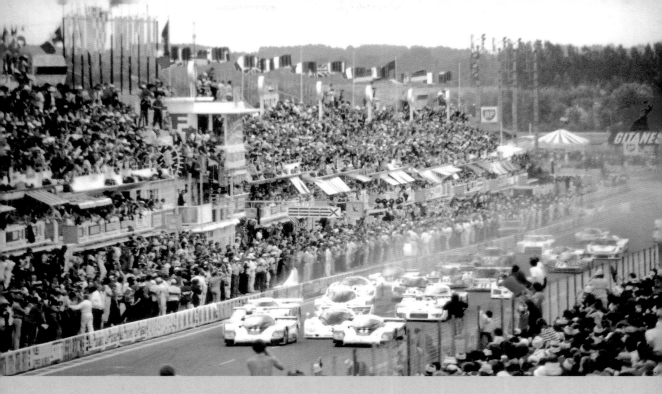

Le Mans, situated right in the center of the town, gives a thousand suggestions to guests who wish to see the race or to those who want to be introduced to a first time around the circuit. "The rooms are reserved from year to year for the week of the race," the hotel reports. It is the strategic point if one wishes to experience this week of madness, to see the drivers' parade, the weighing of the cars, to visit the stands, to rub shoulders with celebrities and millions of spectators who have come from all over the world. The racers often go there. Steve McQueen might have gone there as well, then leap into his Porsche to have supper with his team at Ricordeau's in Loué. The restaurant says, "He came here during the whole shooting."

In 1909, Thomas Edward Lawrence set off alone for a walk in Syria and Palestine. The Bible had revealed ancient civilizations to him. He wanted to get to know them, to live among the Arabs, to speak their language. The effort, the harsh countryside, the tiredness, the bivouacs in the mountains did not worry him in the slightest. He had a taste for difficulties. He learned the dialect and local customs, and thus turned into the perfect candidate for the British secret service. Lawrence took charge of making an inventory of ancient sites in the Sinai. In fact, it involved putting the finishing touches on maps and taking notes. Soon, he came to support the Arab revolt, a fact that prodigiously annoyed his superiors. He persisted. He was on his way to his extraordinary destiny.

Lawrence returned to England after years of combat; he was worn out, depressed, and mentally unstable. He started to write his memoirs *The Seven Pillars of Wisdom*. By then, Lowell Thomas, a journalist more ambitious than the others, had already recounted Lawrence's adventures. He had turned Lawrence into a romantic icon, a warrior desert prince, who was terribly exotic in his white caftan. Together they had mixed truth and falsehood. Lawrence had once been happy with this idea but now he cursed this fame, and his past haunted him. To gain some peace and quiet, he called himself Mr. Shaw. It was under this name that he was found, next to his motorbike on a road in Dorset, one day in 1935. The death was almost banal but it had unbelievable repercussions. The story of "El Aurens," the narcissist, the humanist, the killer, the ambiguous, the uncontrollable figure that nobody really knew, took on phenomenal proportions, invading the newspapers and enshrining him in mystery. Winston Churchill said, "In my eyes, he is one of the most extraordinary people of our time." Lawrence's English publisher took advantage of this sentiment and republished his memoirs. The producer Sam Spiegel bought the rights, and talked to David Lean…

Lawrence had already refused a number of proposals. In 1930, he had even written to the director Rex Ingram to tell him that he had no intention of selling the rights to his book, and that he detested the idea of

# CAMEL RIDING IN THE DESERT

## • LAWRENCE OF ARABIA •
## WADI RUM

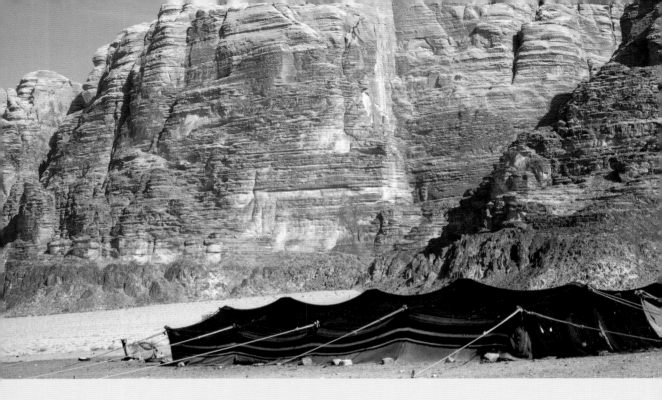

being thus travestied. David Lean nevertheless made the movie, partly in the places described by Lawrence, with an almost unknown actor in the leading role, Thespian actor Peter O'Toole. He arrived on the first day with a dreadful hangover. Lean made him understand that in a Muslim country there was a strong risk of expulsion for such behavior. The actor kept to one bottle of champagne in the evening after work. Alec Guinness, Omar Shariff, and Anthony Quinn were also part of this staggering adventure. It is easy to believe Omar Shariff, who said, "For a career start, it was fantastic."

David Lean said he was disappointed by Wadi Rum initially, but once he became caught up in it "he found that it was the most fascinating place." Most scenes were shot in Jordan—except for those in Aqaba, which had become too modern and was replaced by Morocco. On May 15, 1961, the crew settled under tents in the middle of the desert, in Jebel Tubeiq, to the east of the Saudi border, a landscape of overheated dunes with a water point some 124 miles away. Then the crew left for the region of Petra, "the stone," a legendary site belonging to a dream world that Lawrence had discovered long before his adventure in the desert.

Finally came the well-worn cliff-lined mountains, Wadi Rum, a dry valley of pink boulders, an antique and religious location, an unforgettable setting. You remember the movie journalist who asked Lawrence, "Why do you love the desert?" "Because it is clean," he replied. It is a strange desert, baroque, dug out and polished for thousands of years, which unveils its contrasting shapes that disappear into infinity. *In The Seven Pillars of Wisdom*, Lawrence harangued his troops, shouting, "We will meet in Wadi Rum!"… Yes, we will meet in Wadi Rum, in the one-night camps, under the Bedouin tents, on the tracks of the Nabataeans and the caravans, in the sand-invaded valleys. You will drink tea, sleep under the stars, leave in the early hours of the morning on your mounts, pass by Petra, Mount Nebo, and the Kerak citadel, just as Lawrence did, unconscious, suffering from hallucinations, and obsessed by his dream. "Our little caravan grew self-conscious, and fell dead quiet, afraid and ashamed to flaunt its smallness in the presence of the stupendous hills…"

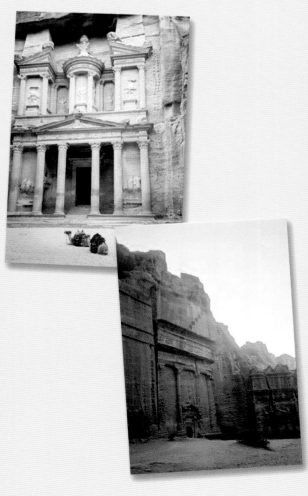

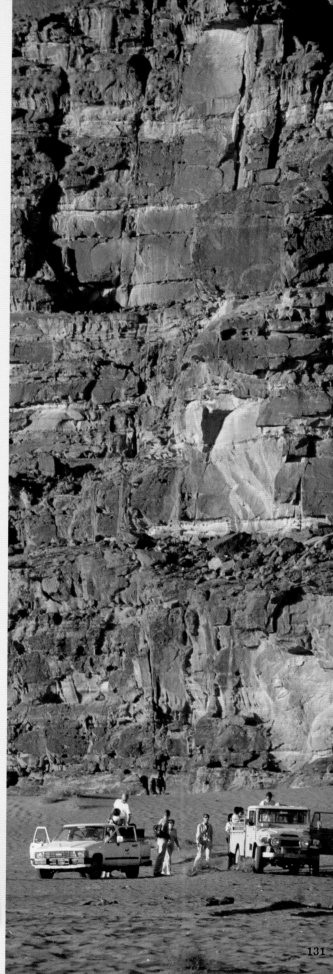

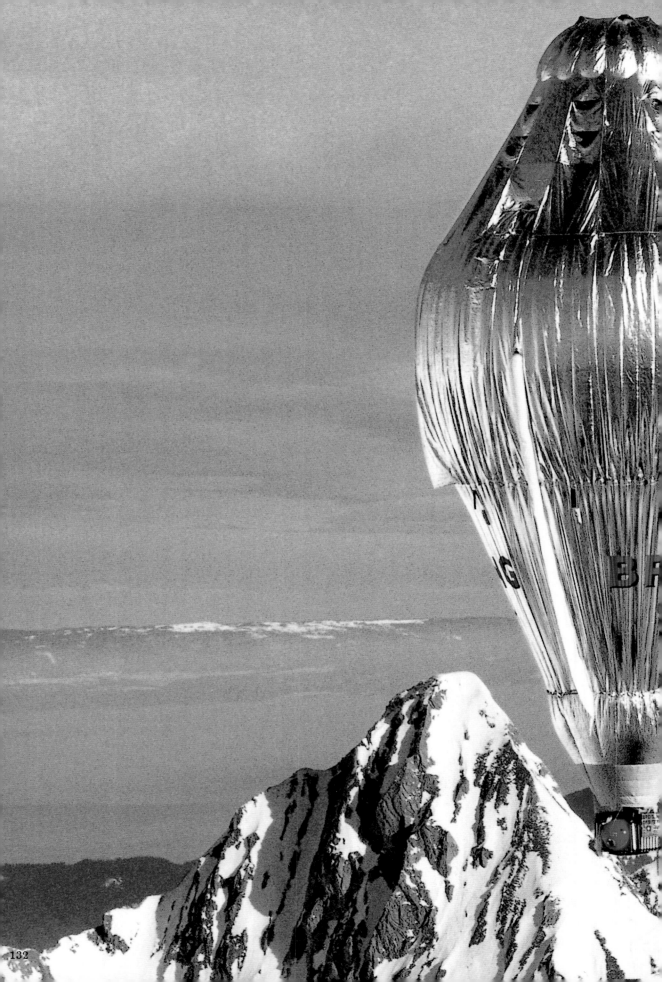

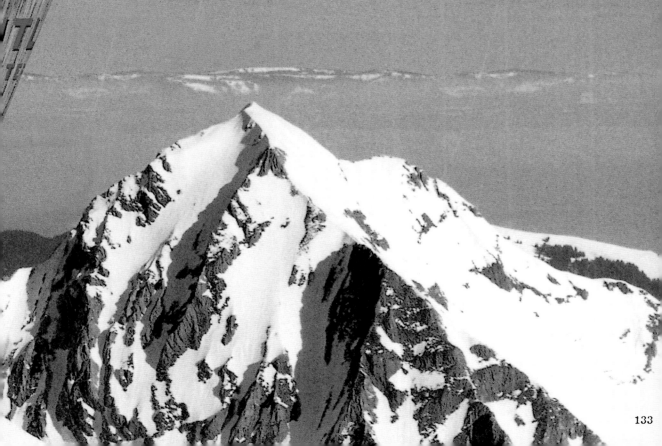

# JOURNEY IN A HOT-AIR BALLOON

## • BERTRAND PICCARD •
### CHÂTEAU D'OEX

On March 1, 1999, the hot-air balloon Breitling Orbiter III took off from the Château d'Oex at 9:05 a.m. toward outer space. The Swiss Bertrand Piccard and the Brit Brian Jones were at the controls. Their aim: to make the first ever round-the-world trip in a hot-air balloon without stopping, without an engine, and propelled by only the wind. To go around the world… A tempting invitation. Irresistible for Bertrand Piccard. The impossible is his forte. His grandfather, Auguste, invented the principle of the pressurized cabin as well as the stratospherical hot-air balloon; he apparently inspired the famous illustrator Hergé with the character of Professor Cuthbert Calculus in the *Tintin* books. His father, Jacques, had worked with Bertrand's grandfather to make the deepest dive in history and to design the first touristic submarine. Brian Jones, had yet another story to tell. He had been keen on hot-air balloons for only about ten years but had been flying since the age of sixteen. Captivated. Determined. Unruffled. More than that even. On board a mammoth envelope (chockablock with electronics and computer technology) bigger than the Tower of Pisa, they flew over Switzerland, France,

Italy, Spain, Morocco, Mauritania, Algeria, Libya, Sudan, the Red Sea, China, Burma, the Pacific, Mexico, Guatemala, Haiti, the Atlantic, the Sahara, Libya and Egypt among other places; they survived flying at altitudes varying between 32,800 feet and 39,400 feet, with jet streams blowing; they crossed two oceans, flew over the Sahara at 145 miles per hour, and landed their incredible Breitling Orbiter III softly in the Egyptian desert after 19 days, 21 hours, and 47 minutes of flight, the longest flight in distance and in length in the whole history of aviation. An absolute record. The Piccard-Jones pair took its place in history.

*Cervin seen from a height of 28,000 feet.*

To go around the world powered only by the forces of nature. The two friends later said they had the impression of holding the world in their arms. A near perfect alliance between man and nature. As Bertrand Piccard said, "Our deep-seated fear of uncertainty and of the unknown is the source of most of our problems."

The rendezvous in the air is still there, at the Château d'Oex or elsewhere, for new projects such as the round-the-world journey in a solar-energy aircraft that Bertrand Piccard hopes to accomplish soon—or for more modest adventures. The sky remains open day and night. The world also. Every

year, for a week in January, the Château d'Oex welcomes people who are fascinated by hot-air ballooning from all over the world…and they launch their fabulous giants.

If traveling is to break with monotony, then this short-haul hop across the continent will give you the feeling of a complete change of scenery. So will the region, with its divine villages, Gstaad, Gruyère, Rougemont, and its valleys, its rivers, its pastures filled with chubby cows, and its old chalets. This is the region that is referred to as the "Pays d'Enhaut" in Geneva. After his trip around the world, Piccard celebrated the event at the Hostellerie Alpenrose in Schonried, not far from Château d'Oex, situated near Gstaad. Guests can read a few lines he wrote in the Visitors' Book in January 2002: "How fortunate that a trip round the world also includes Alpenrose!" It comes as no surprise that the adventurer liked this place, where sports lovers and those hungry for fresh air meet up. Its decor of light wood, its flowered balconies, its bedrooms overlooking the glaciers, its old drawings hung on the walls, and its traditional items give the impression of a family environment. This is the case. For more than a century, the Von Siebenthals' charm

has welcomed guests. Carole and Michel have taken over this little paradise mountain, and they keep up with tradition. He makes miracles in the kitchen. She captivates everyone with her beautiful smile and joyful energy. They're just like friends, in fact.

Chateau d'Oex is the most famous place for aeronauts from all over the world, and the Sky Event crew knows how to turn the trip into a memorable one for the ordinary passenger. It starts at dawn, weather permitting. Excitement increases as the enormous fabric is blown up. Then the time comes to enter the nacelle. A jolt. The structure shudders. And there you go. The bird flies away, high in the sky, floating toward the stars.

# ON A DHOW IN THE RED SEA

## · HENRI DE MONFREID ·
### THE RED SEA

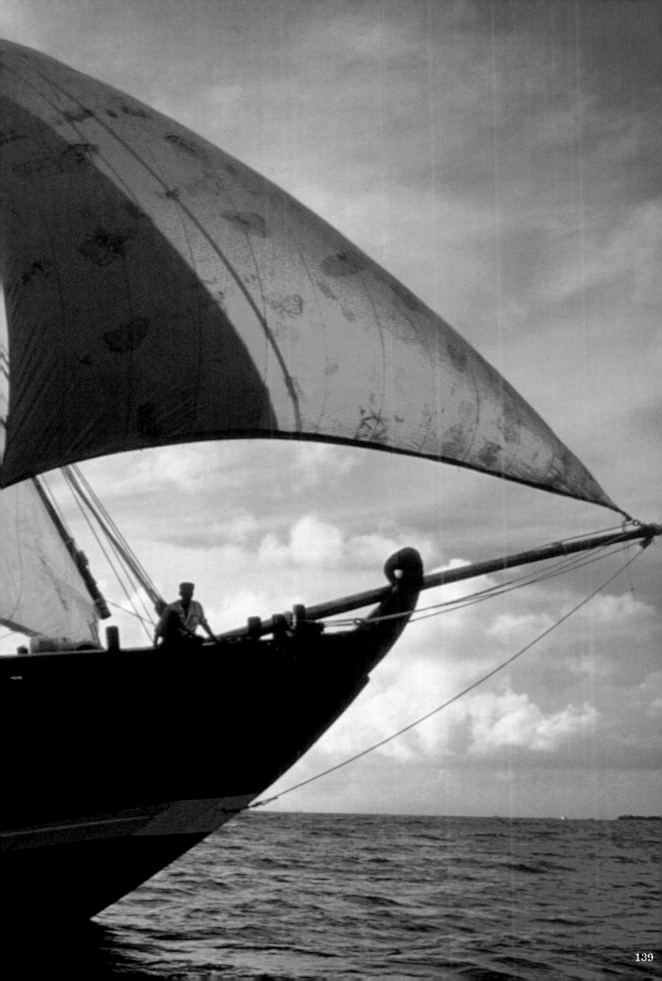

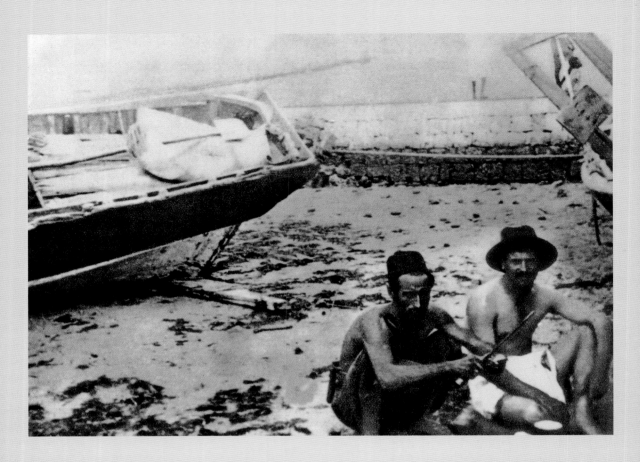

Sanjeeda alone summarizes all the dreams of travel, adventure, and discovery that anyone can have. It is not a boat. It is a *dhow*, a glorious vessel, sparkling with foam, which slices through the water like a dolphin. A boat for a runaway princess or an exiled prince, patiently built year after year, with unusual enthusiasm and a concern for authenticity.

Already an adventure in itself, it is the work of an Anglo-American musicologist, Anderson Bakewell—a friend of Bruce Chatwin and a nomad himself—keen on music from Yemen, Turkey, and China. One day he discovered a photo of an old boat that enchanted him. The picture dated from the fifties. He was in India when he met the captain of the photographed sailing dhow; he was directed to the architect... Fate, providence, luck. The man was 75 years old and did not live far away. He supervised the construction of *Sanjeeda* himself, and Bakewell took the former captain on in his crew as sailing master for the next three years. An eighteen-month construction, and twenty-five men for a unique piece of work, made entirely by hand. In addition, several months were spent in Ajman so that the boat could be fitted out with indispensable modern

equipment. Bakewell wanted to rent *Sanjeeda*, and although he had to adapt certain things, he was sad about having to include modern elements on the boat when they had spent so much time making it similar to the old version. *Sanjeeda* made its first trip in 2000: Dubai-Kochi. The owner's emotion is easily imagined. He thought it was simply wonderful. Today, *Sanjeeda*, "the dependable," can sail off the coasts of Ceylon, Oman, in the Red Sea, or in the

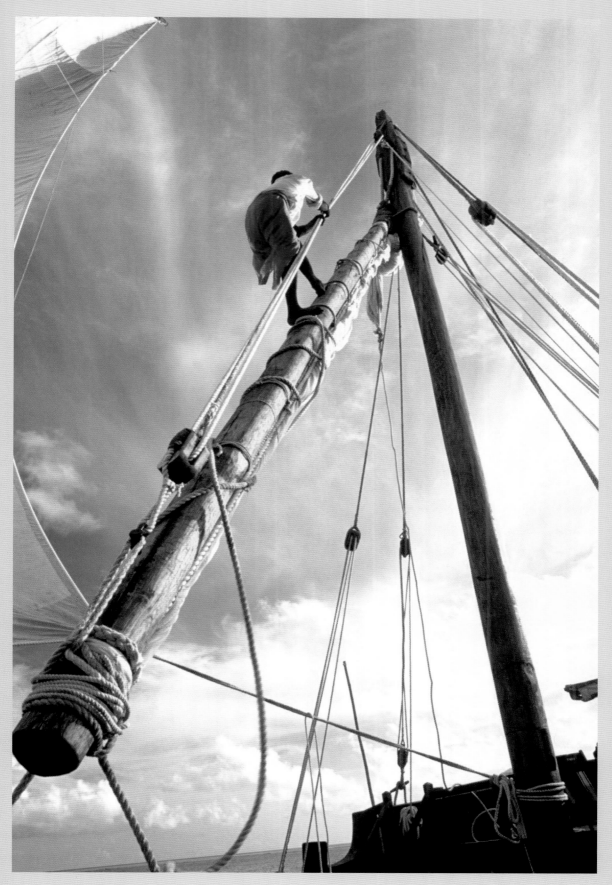

Sanjeeda, *a dhow that encapsulates everyone's dreams of adventure.*

Indian Ocean, just like Henri de Monfreid's much more modest dhow.

Monfreid or wild life with no laws. Monfreid or risk, insolence, freedom, and nerve pushed to the extreme. A slap in the face for conformists and prudent people. When he arrived in Djibouti in 1911 to join a commercial firm, he realized very quickly that he had nothing in common with the middle-class mentality of his French colleagues. Selling coffee door-to-door was not his cup of tea. What sort of work was suitable for him anyway? He had failed the École Polytechnique, had been a chemist, a milkman, a broker, a chicken farmer, and a driver. His father, a painter keen on yachting and a great friend of Gauguin's, undoubtedly inspired him. Monfreid detested colonial life and turned toward the locals. He understood them. He learned their language and blended in with them, thus scandalizing the French community. So much the better. He chucked his job, converted to Islam, bought his first dhow, recruited a crew, and set off to deal in door-to-door gun deliveries. He plundered the Red Sea. Smuggling was one of the local sports. Perfect. He hired a native servant boy and divers, and went into the pearl trade. He built other boats himself, including the famous *Altair*, and ended up at the head of a real flotilla. He went on to hashish and opium trafficking, as well as to the slave trade. And when the consumers' tastes changed, he began dealing cocaine.

A brigand, yes, but also a businessman. Cutting a fine figure at the helm of his sailing dhow—his sharp face and body tanned by the sun, wearing a loincloth and smoking opium—he managed all the transactions himself, sharing the sailors' lot, enjoying the action, the freedom, and living his life from one day to the next. He paid a high price for this life: he was deported to a camp in Kenya under dreadful conditions. On his return to France, he tried to enter the Académie Française but was not elected; he wrote untiringly, went on TV, continued to supply the Paris market with illicit products, and finally closed this incredible album in 1974, at the age of 95. Advised by another adventurer, Joseph Kessel, he described his existence in *Secrets of the Red Sea, Hashish, Sea Adventures, La Cargaison Enchantée, Pilleur d'Épaves*...overall, in more than seventy works. A unique testimony (on the Red Sea, Kenya, Ethiopia...) passed on to us through Monfreid's books, photos, and watercolors. "His work speaks to those who set off on a journey without taking an airplane," said his grandson Guillaume de Monfreid. Few belongings. The nomadic instinct. The desire to discover, to go toward others. Everything offered by *Sanjeeda*, by a crew enamored with both boat and sea, by its astonishing Indian chef, and by the teak deck upon which one walks barefoot; a unique, simple maritime environment, which can be compared to a new world.

# A MASAI HUT
# IN THE BUSH

### • MOGAMBO •
### TANZANIA

Clark Gable, Ava Gardner, Grace Kelly. Africa and John Ford. As an article in the *Times* said, "Gable plays his part of a male with all the carefree attitude of a man who has been doing just that all his life." He was then 52 years old, with his career behind him. The film was a remake of *Red Dust*, in which he had already starred with Jean Harlow—used to highlight MGM thoroughbreds. Gable again took up his part as a white hunter hired by a scientist and his wife for a safari. When another woman arrives unexpectedly, the classic trio is set.

Grace Kelly was, of course, the icy wife. Ava Gardner brought along complications, as always. The plot was of little importance. The natural sets were what held the eye, along with the magnificent studio animals, added to those shot in different African countries. Uganda, Kenya, the Congo, and Tanzania—still called Tanganyika in 1953. Gable had lost Carole Lombard a few years before. He drank too much. His wrinkles were more marked than those of his actor friends. His tired face was nevertheless still on the cover page of *Look, Picture Show*, or *Film News*, and he continued to shoot several films every year. Grace Kelly was soon to be of serious interest to Alfred Hitchcock. Ava Gardner

had been married for two years to Frank Sinatra, who joined her during the shooting. Once all the details had been organized, the team left on safari for four weeks. A camp was set up near the Kagera River, where Tanzania, Uganda, and Rwanda meet. It was the biggest safari ever seen in West Africa. There were two hospital tents, a dance floor, a recess tent, a tent for the motion picture show, a landing runway, twenty hunters, and a full-time crew of five hundred people from Africa and the rest of the world. Bunny Allen, the professional British hunter who had just found the locations for the film *The African Queen*, was in charge of organizing the whole thing. Established in Africa since the twenties, he was famous for taking on safari a good number of well-known hunters such as Finch Hatton and Karen Blixen, the Prince of Wales, and Aly Khan. He embodied the glamour of great safaris, the marriage of Hollywood and Africa: all the spirit of adventure in the fifties. His safaris could be described in three words: *Romance, luxury* and *excitement*. Allen surrounded himself with people who knew perfectly the places and the hotels they would recommend. He could answer the most ludicrous questions. He managed to discover a hair dryer right in the middle of the

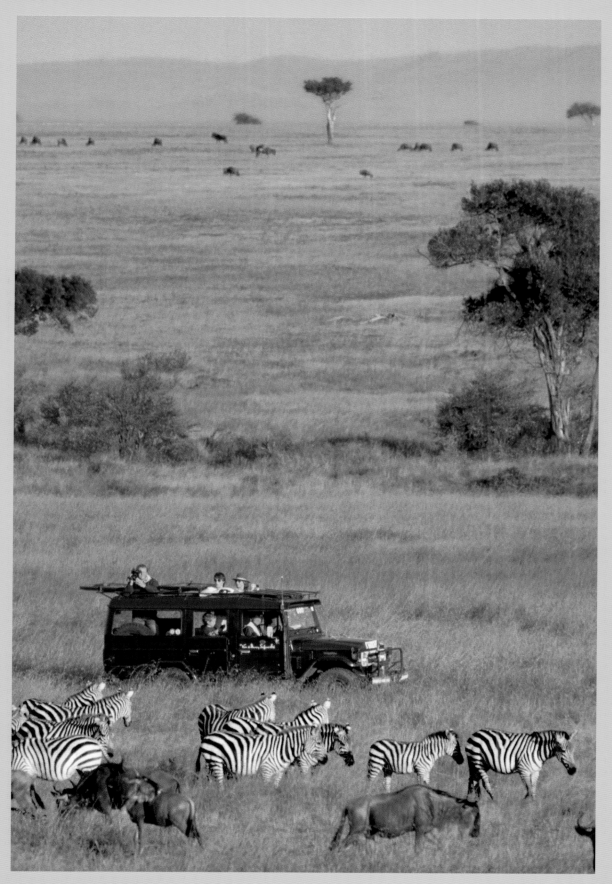

*That atmosphere of the great safaris...*

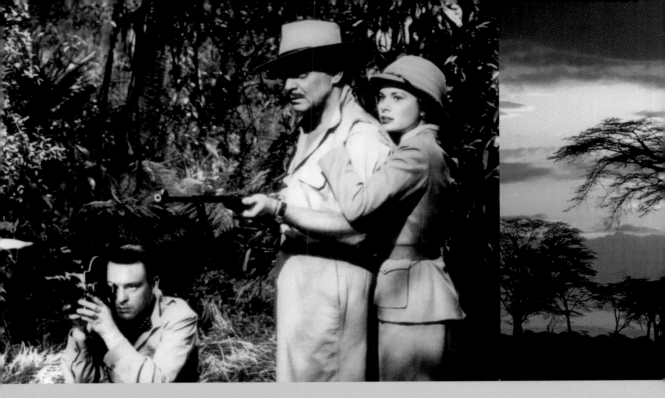

jungle. He gave his guests all the indispensable information to prepare for the adventure, and above all, to make them forget their habits. According to him, "It's the camp smoke. Watching a fire. Seeing it sparkle. And the stars… You get the best out of people when they're sitting around a fire camp. People forget Belgravia and Fifth Avenue and finally become themselves."
Clark Gable loved the atmosphere. Grace Kelly, too. And on Christmas Eve, Frank Sinatra emerged from the jungle with cake and champagne, singing "White Christmas."

The atmosphere of great safaris, the English clubs in Zambia, Botswana, Kenya, and Tanzania, the territories of warlike tribes… Such landscapes dazzled Hemingway, and still haunt modern hunters who dream of the obsessive heat, the great lakes in the heart of Africa, and the "Big Five"—the lions, the leopards, the elephants, the buffalos and the rhinoceros. Some places offer majestic safaris, exactly those of which dreams are made. The Ngorongoro Crater Lodge, to the north of Tanzania, is described as the most beautiful premise in Tanzania, and its region

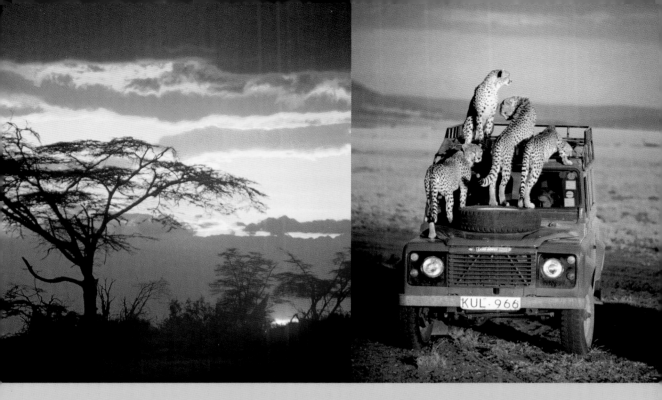

presents a rarely achieved landscape diversity. It is an African village overlooking the Ngorongoro crater, one acknowledged as a protected zone, with bedrooms built just like Masai huts, crystal chandeliers, heavy sculpted doors, and thick carpets. The Big Five are there. Guides accompany their guests from camp to camp, preparing itineraries from day to day, organizing tailor-made schedules. The hotel is extravagant. Excessive. A baroque folly right in the middle of the bush. People say that the place looks just like a real Hollywood set. That is just as well.

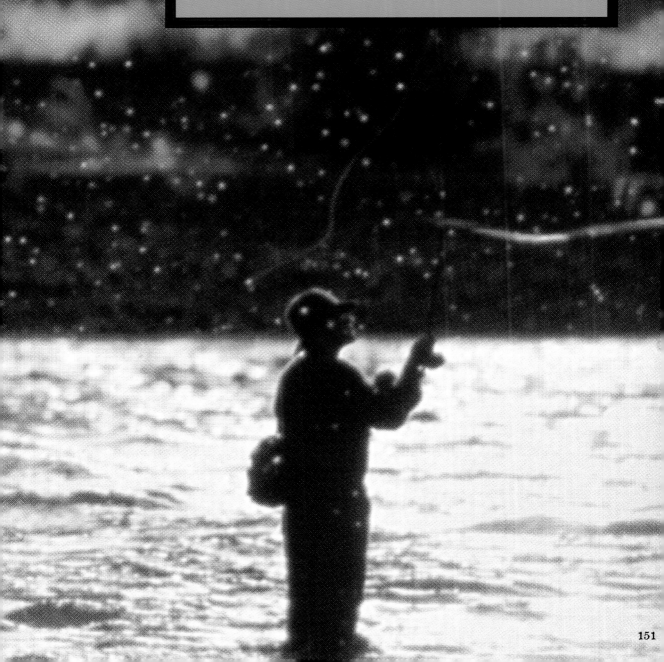

# FLYFISHING IN MONTANA

### • A RIVER RUNS
### THROUGH IT •
### MONTANA

Flyfishing adepts know it well. Montana is the state where you can fish in the most famous rivers of the world. The Big Hole, Gallatin, Missouri, Madison, Yellowstone, and Beaverhead… You will find rainbow trout, brown trout, cutthroat trout, brook trout, lake trout, *kokanee* salmons, perches, pikes, barbots, carps, sturgeons, moonfish… Montana is famous. Its rivers are legendary. They flow in the novels of the great American writers Jim Harrison, Thomas McGuane, and Richard Brautigan, who have lived or still live around here.

Norman Maclean was 74 years old when he wrote *A River Runs Through it*, an autobiographical novel that described the life of Norman, Paul, and their father—a pastor and flyfishing fanatic—in Missoula, Montana, at the beginning of the twentieth century. Norman is earnest—too much so, undoubtedly. Paul has little self-control and leaves chance to decide everything, particularly the irreparable. Fishing and days spent amidst the rapids with their father bring them close. "In our family, there was no clear line between religion and flyfishing"… On the surface, it is the story of a family and fishing. Then the symbols come to light, along with the metaphors so dear to Maclean. Paul goes about fishing in the same way he goes about life, with a lasso. He casts his silk with a precise gesture, and off it goes dancing in the sky. The trout bites. He reels some of his silk in, then waits and lets the fish grow tired. Norman and his father watch him. And it is this complicity, full of nuances, that holds the family together.

In order to shoot these superb scenes, Robert Redford chose, among others, waters in Livingston, the River Gallatin, near Bozeman. Other producers had already made offers to Maclean to make a movie out of his novel. The actor William Hurt, another fly fisherman, had even gone to do a bit of pike fishing with him, hoping to convince him. The writer ended

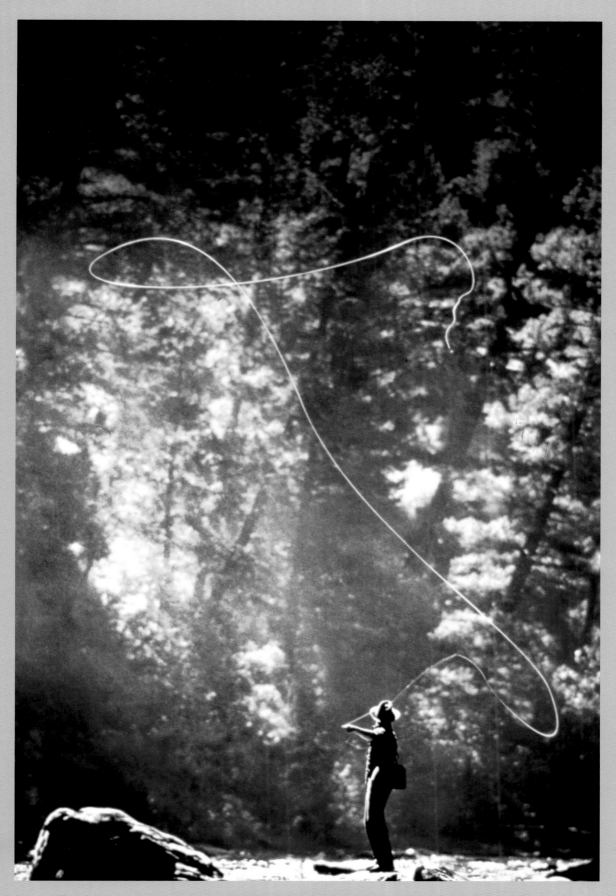

*Paul goes about fishing in the same way he goes about life, with a lasso.*

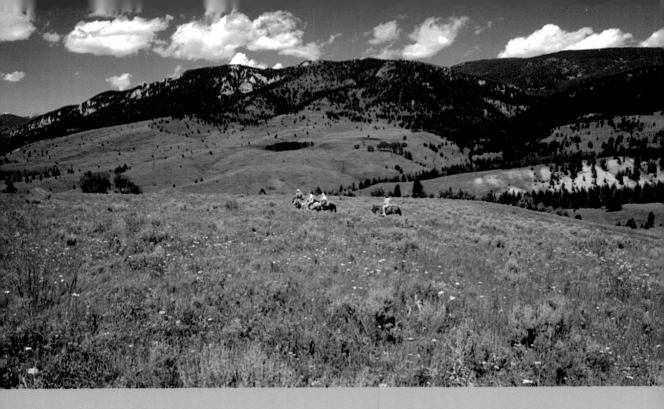

up agreeing that Hurt was a fairly good fisherman but not good enough to play the part of his brother, which the actor had his eye on. Maclean accepted Robert Redford's offer because Redford promised he would concentrate on the fishing. Robert Redford's voice was that of Norman, the one telling the story. Craig Sheffer was Norman; Brad Pitt was Paul. Both actors took casting lessons for the movie, but famous professional fishermen dubbed them for the main scenes. The young Jason Borger, the son of a famous fly fisherman only just out of the University of Wisconsin at the time, and who had fished from childhood, cast the silk that goes off to dance in the sky in the famed "shadow casting" scene. "I grew up with fish, flies and water," he said. And it is this picture of Paul spinning his line around majestically in the middle of the silvery river, that was finally chosen for the movie poster. "An incredible experience," Borger said. "Robert Redford understood flyfishing and wanted to be sure that everything would be

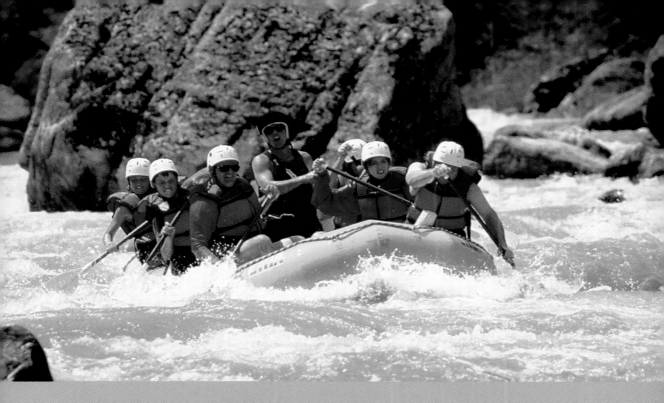

done right." Shadow casting was no exception. "Every fine fisherman has a few fancy stunts that work for him and for almost no one else," wrote Maclean. Jason Borger makes the movement come alive over the waters of the River Gallatin. This gesture of a moment went all the way around the world, and remains in everyone's memory.

It is this same magic moment that all those who go to Rainbow Ranch Lodge, near Big Sky, on the River Gallatin are looking for. There it is, Paul's river, prancing from Yellowstone Park to the Missouri River. The original ranch dates from 1919, and over the years the improvements made have only enhanced its charm. One does not come there only for the fishing, the atmosphere, or the precious sensations, but also for the horse riding, the escalade, the skiing in winter, the ideal isolation, the warm rustic decor, the large candelabras made from deer antlers, the soft leather sofas by the chimney, the restaurant and its exceptional wines, the view over the river, the magnificient nearby prairies, full of flowers when the sun is out, the relaxed elegance—sympathetic, never pretentious. A whole collection of divine little things in the middle of nowhere, mixed with the lively water that you hear as soon as you awake.

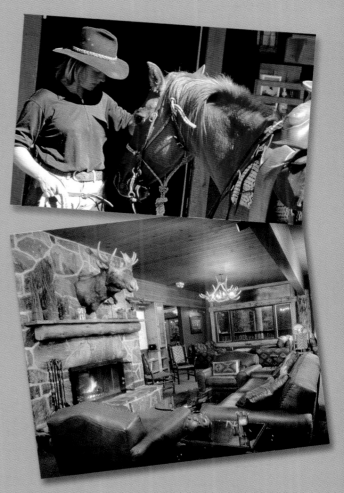

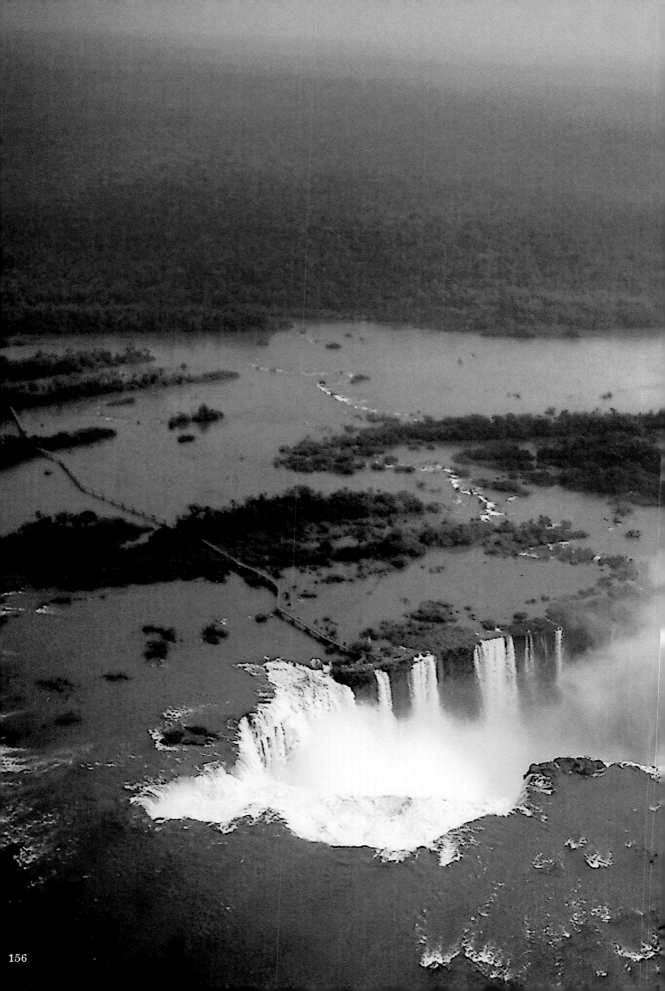

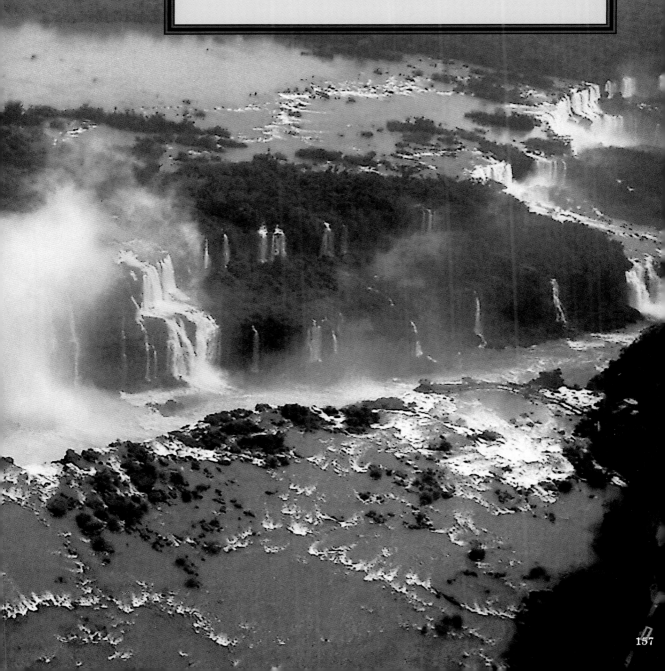

# MISSIONS
# IN THE
# VIRGIN FOREST

## · THE MISSION ·
## IGAZÚ

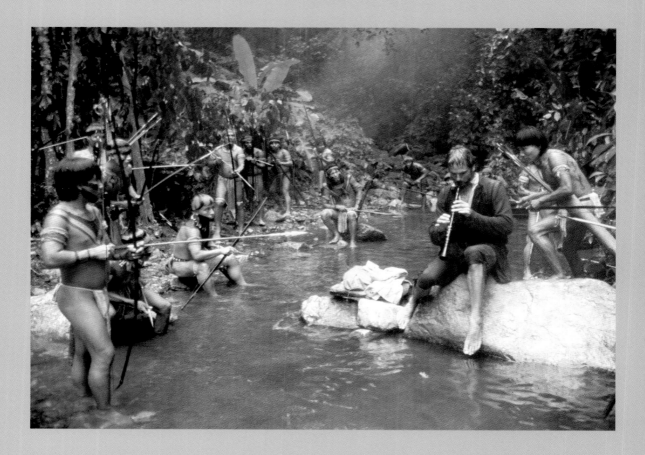

Yacutinga Lodge's visitors' book overflows with praises, enthusiastic comments, joyful drawings, friendly notes. Nothing surprising. The hotel, or more precisely, the natural refuge, fully deserves them. The lodge resembles no other. Nothing here has been seen before. No misleading luxury, no advantages that turn out not to be so, no bluff, no showing off. Luxury and advantages are in fact everywhere, especially in a series of features unlikely to be found in a location as far away as this one. The jungle totally envelops the main building. You enter the first room, a magical cavern hidden away under the branches. Dry creepers, tumbling down the walls in spiral. You breathe a delicious perfume of *Euterpe Edulis* palm tree wood. The colored chairs are made of large stones, and are level with the ground. There is a funny sort of coffee table made out of a tree trunk cut lengthwise, from which green plants burst. A load of amusing objects. Outside, in the proliferate jungle, houses have been built between the trees, decorated with much imagination, trunks transformed, shards of bottles integrated into the walls to form fabulous stained-glass windows, brownstones in the untouched and cool shower rooms, and trees springing up in the

middle of bedrooms. This is *Selva Misionera*. The missionary jungle. An astonishing refuge for wildlife, where plant and animal species are plentiful. The Lodge guides know all of them by heart. The refuge moreover protects several endangered species. You have supper in the loggia above the salon. The food is simple and freshly prepared by a cook who is as talented as he is inventive. Then you go outside for a yerba maté, the drink of the Guarani indians, and listen to stories and tales told by one of the guides around a fire.

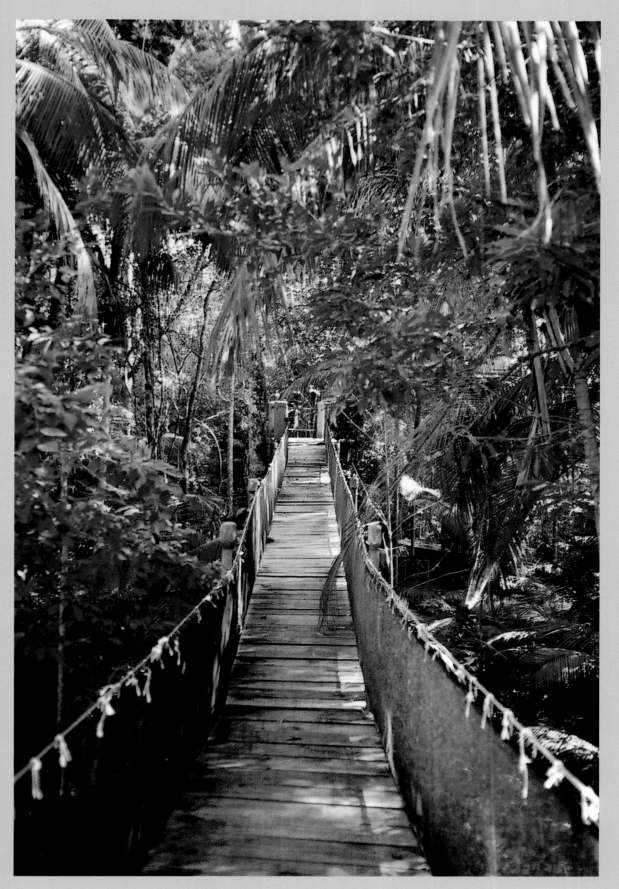

*The bridge of creepers at Yacutinga Lodge.*

The fantastic Iguazú Falls, shared by Argentina and Brazil—a UNESCO World Heritage site—are only about three hours away by road...or rather through a red earth path full of potholes, in the middle of the jungle after Puesto Tigre. Almost the same red earth that was trodden on by Jesuit missionaries in the seventeenth and eighteenth centuries. What is now known as Provincia de Misiones was then a fantastic tropical forest, the Guarani indians' domain. Spain and Portugal soon quarreled over this land and over the evangelization of the natives. The territory was then divided between the two kingdoms, which gave rise to enormous devastation. A story that is wonderfully told by Roland Joffé in his movie *The Mission*.

In the film, Father Gabriel (Jeremy Irons) wants to establish a pacifist community among the indians. He meets a reformed slave trader (Robert de Niro). Both aspire to work for the mission. A project that is doomed to fail. The opening scene, with the extraordinary Iguazú Falls, is unforgettable. Two hundred seventy-five terraced falls hurling themselves down one after the other, creating an enormous hollow in the ground, surrounded by the overabundant

jungle… The apocalyptic thundering of the water. The mist that envelops the already stunning picture with a cloud of white cotton wool. The movie captures all the unbelievable beauty of this fascinating sight. Roland Joffé took shots of the falls and the ruins of San Ignacio Mini, a former seventeenth-and-eighteenth century pueblo, not far from Yacutinga, also a UNESCO World Heritage conservation site. It was Robert Bolt, the screenwriter of *Lawrence of Arabia*, who brought Joffé the project. Fascinated, the latter decided to go off on the tracks of the Guaranis. "Of course, there was nothing left of them," he said. "They were a proud nation, and that touched me tremendously. To such an extent that I decided to tell their story. It was like meeting someone in the street who tells you something about himself, and you say to yourself that he has a life and an experience that everyone should know about." The film was awarded the Palme d'Or at Cannes in 1986, and two Golden Globes in 1987, one for Robert Bolt's screenplay and one for Ennio Morricone's music. It is a journey to the heart of extravagant, staggering, furious, miraculous, and desperately excessive nature; over red earth paths, into the green regions, glistening, oozing, full of birds… Also a journey into the heart of humanity.

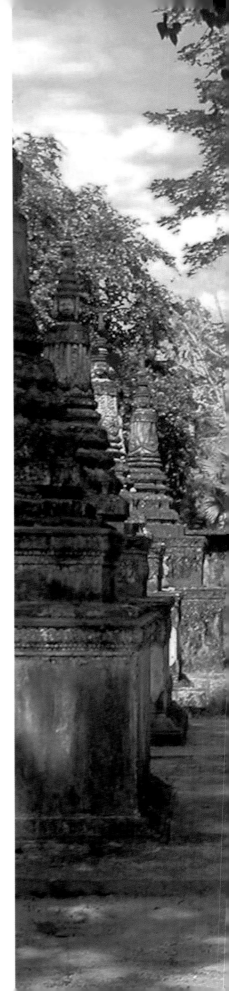

When William Somerset Maugham arrived in Angkor in 1923, he had already been to Colombo, Mandalay, and Thailand, crossed Burma on the back of a donkey—boosted with gin and tonic—crossed plains, rice fields, and mountains, caught a train in Lopburi, malaria in Mandalay, and had sailed on a cockroach-ridden old tub in Cambodia, up to Kep. A rather normal thing for someone born in the British Embassy in Paris. Maugham always thought travel triggered creativity. He loved to go from one place to another, leaving behind ties, obligations, and duties. He also loved the unknown. He said that he often tired of himself and that each trip brought something different to his personality. He left London, where he had started out as a doctor, and settled in France with his wife, Syrie, and his friend Gerald Haxton. In fact, he spent his time traveling, always looking for a new atmosphere, an exotic environment for his stories, and people to describe; he had a definite gift for human contact and mixed effortlessly with all those he met, wherever he happened to be.

His trip to Angkor enchanted him. "What gave my trip to Angkor such exceptional importance and put me into a state of mind that suited such an adventure, was the extreme complication of the journey to get there." The word has been unleashed: complication. The essence of any really successful journey. He arrived first in Phnom Penh; from there he caught a steamboat, then climbed onto another, then onto a sampan, and into a car…and finally, the towers of Angkor Vat appeared. "I had never seen anything in the world as admirable as the temple of Angkor," he wrote simply. He was not the sort to look for convoluted words. He did not go for rare epithets. He improvised, said what he saw, naturally, with mischief and humor. His steps led him into the jungle, along paths where temples, heads of Shiva, monumental doors, main courtyards—all in all, a prodigious "masonry in ruins"—stood spectacularly, tottering under the weight of lichen, weeds, and moss. The roots of the trees were twisted like snakes on the stony ground. Just like those who go there nowadays, Maugham climbed the broken steps of steep stairways and

# AT THE FOOT OF THE KHMER TEMPLES

## • SOMERSET MAUGHAM •
### ANGKOR

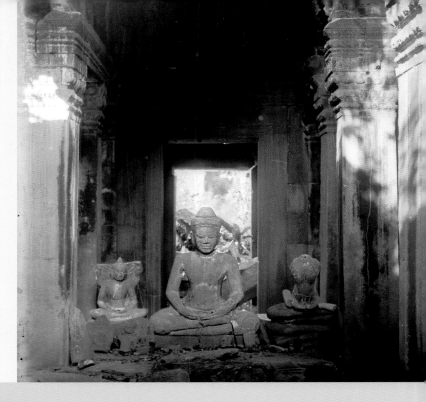

# DINING GUIDE

opened a path for himself along the corridors. He went through vaulted rooms damp with humidity, and passed in front of bas-reliefs representing elephants, and dancers, finally arriving in front of upturned pedestals that had once carried gods, then galleries, terraces, and large moats obstructed by the furious vegetation. And just like travelers today, he imagined…what the place must have been like before the restorations. The old city of the Khmer kings. A village temple. Fifty odd monuments. Angkor Vat, the sanctuary of the forest isolated by moats. Angkor Thom, the inner royal city. Ta Phrom, the Buddhist monastery now devoured by giant trees and roots… One of the many memories to which he treated his readers in *The Gentleman in the Parlour*. Where did Somerset Maugham stay? He might have chosen the Angkor Grand Hotel, in Siem Reap, at the gateway of the temples, but the legendary palace only opened in 1932. Nevertheless, he is celebrated there, with other palace flies who, just like himself, left

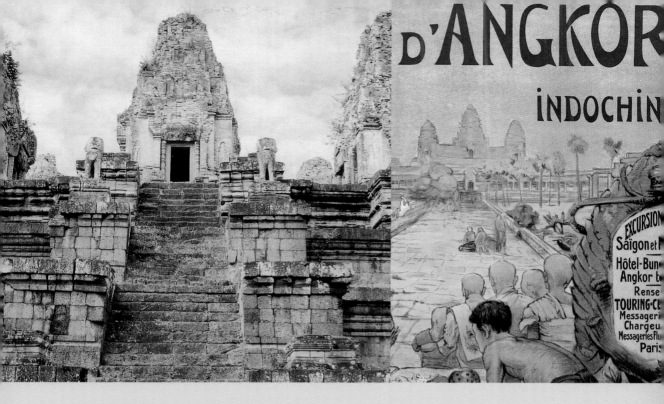

traces in Bangkok or Singapore. Refurbished not long ago in the Khmer, Art Deco, and Colonial style, it has resisted everything; retaining all its magic, with its elevator—dating from the French protectorate period—nonchalant ventilators, elegant bedrooms overlooking the banana tree orchard, and indestructible exotic luxury. Meet up in the Travellers Bar, amongst nineteenth-century photos of Angkor. Ask for a Million Dollar Cocktail, immortalized by Maugham in *The Letter*. Go into the library to look at art books, guide books, and ancient maps. The hotel now belongs to the prestigious Raffles group, but it still breathes of the Cambodia that delighted globetrotters and adventurers from the Far East so much. This is the Cambodia of the first archeologists, of great travelers, of foreign journalists and writers, of Pierre Loti, who slept on a mat in Angkor Vat, and Arthur Miller, who arrived just at the time when Prince Sianouk was overthrown (he more or less had to buy a coach to get back to the Thai frontier).

Linnet Doyle is young, stunning, and rich. She has everything going for herself, and on top of that, she has just married her best friend Jacqueline's very attractive fiancé. The couple go off on a cruise aboard a luxury steamboat on the Nile, where they bump into Jacqueline and meet a brilliant Belgian detective. The latter quickly starts thinking this situation is a little too idyllic...even more so when Linnet is found with a bullet in her head.

In 1978, Peter Ustinov donned Hercule Poirot's three-piece suit for the first time as the Belgian detective. A part that was made to measure for this unclassifiable actor, full of talent and humor, who started his career in cabaret at the age of 17, directed films, wrote over twenty plays and novels, was a screenwriter, a conductor, a novelist, a TV presenter, a UNICEF ambassador, and the founder of the Global Harmony Foundation, a well-known charity. He had played every role, had succeeded Orson Welles at the Académie des Beaux-Arts in Paris, and he could not allow a specimen like Poirot to pass him by. From the promenade deck of the Sudan Steam Ship Sudan (called Karnak in the movie), he contemplated the view of the Nile banks while employing his untiring "little gray cells." "I loved playing this role," said Sir Ustinov. "But I knew that I did not correspond exactly to the character described by the author. I tried to make him credible in my own way by being as relaxed as possible and by speaking English in a certain way." He achieved this to perfection. A glimpse of the cast: Mia Farrow, Lois Chiles, Maggie Smith, Bette Davis, Jane Birkin, David Niven, and Angela Lansbury... The pride of show business. They went on location to Egypt, some seventy years after Agatha Christie's first journey there. At the time, she was not yet called Christie, but Miller. She was far away from thinking then that she would return one day with an archeologist husband and write a novel. Just as Christie did back then, the crew stayed at the Old Cataract in Aswan—where the book was actually written—and at the Mena House in Cairo. They set off to discover the Giza, Luxor, and Karnak pyramids, the Abu Simbel and Amun temples,

# AN EXCEPTIONAL NILE CRUISE

## • DEATH ON THE NILE • EGYPT

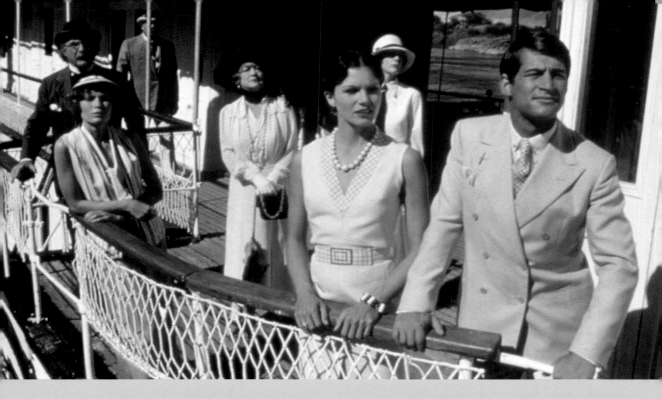

and walked around in the Hypostyle Hall, with its papyrus stalk—where a stone will inadvertently fall in the movie. But the major part of the movie was shot on the Nile, on board the superb Sudan Steam Ship Sudan. Another kind of museum, dating from 1885, offered to King Fouad by Queen Victoria, it enchanted rich tourists during the prewar period. Magical service and setting. A slice of bliss and poetry that sails from Luxor, Esna, Edfu, and Kom Ombo to Aswan. Let us cite, for the pleasure of pronouncing the names, the El Wali, Nazly, Farida, Farouk, Fayza, and El Salatin suites... The promenade deck and its

rattan seats, the light wood and mahogany cabins, the bar salon with its panoramic view, high stools, well-padded armchairs, and old piano, they all saw Hercule Poirot and his friends going by, meeting and observing one another, drinking scotch, and playing cards, just like travelers in King Fouad's time, happy tourists who came from from afar to discover the river that fertilizes the earth. They too found themselves at the foot of the pyramids, in front of landscapes unchanged since the times of pharaoh; they rode during the day under the blazing sun, and returned in the evening to their steam-houseboat salon, wearing

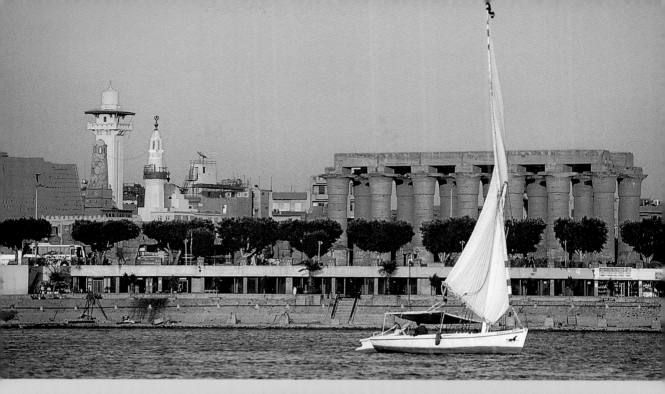

evening dresses and dinner jackets. From Luxor to Aswan, they had more than enough time to go off on expeditions, to admire the docked feluccas, the embankments flowered with white ibis and opulent date trees, and to talk, peacefully ensconced in large cane armchairs in the shadow of the gangway. They only thought about their journey aboard the sumptuous floating hotels, and made comments about the latest archeological discoveries, while reading newspapers that apparently arrived in the reading room as regularly as in any Pall Mall Club.

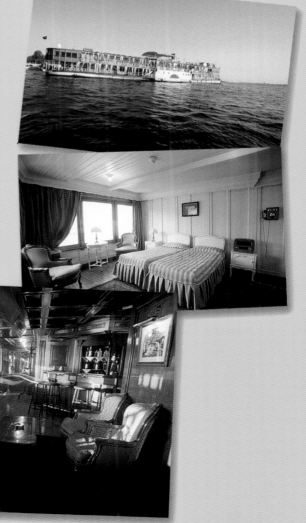

There it is at last, the Relais des Monts! Right at the end of a sinuous and stony road, camouflaged just like a secret hiding place, and with rivers and canyons that make you feel as if you had an explorer's soul. The vegetation is abundant. You arrive at the summit of a sharp bend that dominates the whole valley. You hesitate for a moment, perplexed. Still a few more yards yet. And suddenly the Relais des Monts appears in the midst of untouched wild nature.

In the eighteenth century, it was inhabited by the five daughters of an aristocrat who had been shot during the French Revolution. The property was then abandoned for a long time—until the arrival of Claudine and Jean Laboureur. They came from Africa. They immediately loved the spaciousness, the location, and they started to get down to work. It is an unusual and rare guesthouse, wonderfully protected, remarkably maintained, located above the gorges du Tarn. The view is as perfect as a postcard. The bedrooms are called Victoria, Estelle, and Manon, the first names of grandchildren associated with Victoria Falls. It's a mix of Africa, an English cottage, and French elegance in the most astonishing setting that's ever existed.

The Tarn, Mount Lozère, the Cévennes, gullied valleys, steep rocks, streams and torrents, the maquis, the beech forests… A place for Robert Louis Stevenson. The Scotsman spent his childhood at the foot of Edinburgh Castle. His father and grandfather were famous lighthouse builders. His world was full of magical decors, history, and mystery. A universe that helped him to put up with tuberculosis. But he was not the sort to complain. He was born free as air. For him, nothing was worse than giving up all the possibilities of life by staying in a living room at a constant temperature. In

# DONKEY TREKKING

## • ROBERT LOUIS STEVENSON • CÉVENNES

1876, Stevenson was 26 years old and had just returned from an expedition by canoe from Anvers to Paris. He lived in France and had met an American woman, Fanny Osbourne, at an Inn in Grès-sur-Loing. She was nearly ten years older than he was, married, and a mother of two children. He followed her to California, married her, and took her to where it was warm, to the southern islands, the Marquesas Islands, Hawaii, and Samoa while continuing to write stories, tales, novels, and fables one after the other, from *Treasure Island* to *Dr. Jekyll and Mr. Hyde.*

Fanny's divorce took some time to come through. So Stevenson went off again. His theory was that the outdoor heals. In September 1878, he caught a train to Monastier-sur-Gazeilles, bought a donkey called Modestine for 65 old francs and a glass of cognac. Equipped with a revolver, a pocketknife, an alcohol lamp, a frying pan, candles, tins of sausages, a cold leg of lamb, an egg whisk, a bottle of Beaujolais, and a blanket, he loaded Modestine and went off to St. Jean du Gard under the eyes of flabbergasted peasants. Twelve days. A 124-mile walk. He camped in forests, washed himself in rivers, lived in the fresh air. Dangers abounded: the Gévaudan beast, the cold, the wind, the rain, wolves, and thieves... Pleasures also: the kindness of ordinary people, meeting jovial monks, and more of other life's surprises. And then there are the walks and the hikes. Stevenson said it was difficult to define which moment was the best:

putting your rucksack on or taking it off. He added that one should always travel alone, freedom being essential on a hike, as is breathing, looking, throwing away your watch, or forgetting time and seasons.

The GR No. 70, or Stevenson Trail, follows the writer's footsteps. The boldest trekkers rent a donkey from one of the lodging halts indicated in the guidebook published by the R.L. Stevenson Association. Whatever the means of locomotion you chose, you must see these mountains, these forests, these villages perched high up, these limpid streams, these strange caves, these gorges over which falcons fly, these chasms, these unsuspected castles, and these mountains, which conceal astonishing guesthouses where it feels so good to sit down after walking in this unusual, majestic, and supreme region.

# A SAFARI
# IN THE WILD

## · THE AFRICAN QUEEN ·
### UGANDA

Africa, 1914: Rose, the sister of an English Methodist pastor, decides to flee from the war and the Germans by going down a river onboard *The African Queen*. The old tub belongs to Charlie, a rough sort of fellow who is particularly keen on gin. The expedition, across the worst corners of the jungle, turns out to be as explosive as eventful…

When the Englishman C.S. Forester wrote *The African Queen* in 1935, he was far from imagining that his novel would become a legend in the history of motion pictures. The book was reasonably successful but not a real triumph. Indeed, the author was mainly famous for his novels depicting the adventures of Captain Hornblower, the Pacific adventurer. Katharine Hepburn was Rose. Bogie, Humphrey Bogart, was Charlie. John Huston directed the whole thing. He had just finished shooting *The Treasure of the Sierra Madre* in Mexico, and the idea of crossing the world and to get to Africa—where he could hunt—delighted him. Several actors, including Bette Davis and David Niven, had been approached about the leading roles. However, John Huston offered the part to his friend Bogie, who accepted over a drink at Romanoff's. Then Katharine Hepburn loved the book and quite saw

herself as Rose. She identified with the character, a woman just like herself: original, full of principles and education, but concealing an invaluable resourcefulness. She had never worked with John Huston or with Humphrey Bogart, but she held them in esteem. The deal was sealed at their first meeting.

The movie starts in a small village that has been burned by the Germans. Rose, who lives there with her brother, is distraught. She agrees to board Charlie's old tub. Very quickly, the strict spinster has difficulty putting up with the alcoholic boaster and his dubious hygiene. The personality clash is full-blown. But in fact, it is above all the setting that you remember: muggy Africa, wild rivers, phenomenal

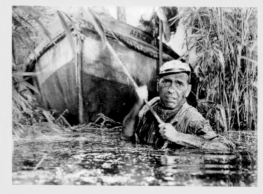

*Katharine Hepburn's adventure with Bogie and John Huston.*

vegetation, with trees, branches, creepers, and humid, deep and inextricable forests. The film was shot in the Belgian Congo at first, then for two months in Uganda, between the Kabalego Falls, Lake Albert, and Port Butiaba. Katharine Hepburn had always said she would never stay anywhere that did not have a bathroom. But there she took showers, slept outside, put up with the unforeseen circumstances of the jungle and with the snakes in the toilets... She brought back numerous souvenirs from the trip: photos, notes, and things that were auctioned after her death, in 2004, at Sotheby's. The shooting was hell for everyone, thanks to all kinds of beasts, malaria, dysentery, and other factors. Exhausting. Except for Bogie and Huston, whose stomachs, according to Kate, were apparently so well lined with alcohol that no germ could possibly have existed there. It was rumored that Bogie even brushed his teeth with scotch. Huston's friend, the screenwriter Peter Viertel, recounted the shooting in Uganda in his book *White Hunter, Black Heart* (of which Clint Eastwood made a movie), describing in

particular John Huston's pathological obsession with elephant-hunting, an obsession that annoyed Viertel so much that he left the film set.

Uganda is a country of frontiers. With Sudan, Kenya, Tanzania, Rwanda, Zaire (the former Belgian Congo). The Paraa Safari Lodge, built in the heart of the Murchison Falls National Park during the fifties, still opens its gates "to bold travelers." Originally, Queen Elizabeth had been expected to visit, and the lodge had been called the Royal Cottage. Winston Churchill and Ernest Hemingway have both admired the same view of the Nile, called the White Nile, which goes as far as Lake Albert. The hotel organizes excursions on the river right up to the bottom of the falls, where guests can spend days with hippopotamuses, crocodiles, baboons, elephants, and the innumerable types of birds, in this incredibly varied park—the pride and joy of the country. A country that Huston was fascinated by and that Churchill nicknamed The Pearl of Africa.

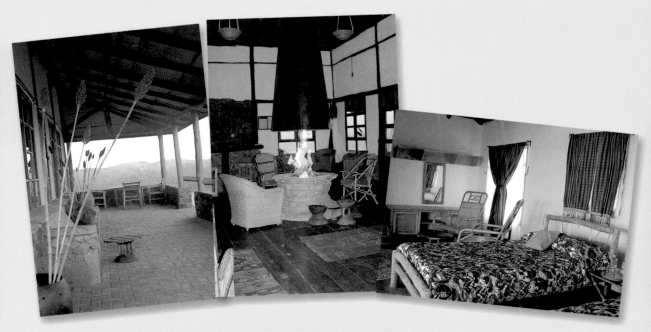

# THE LAND OF DRACULA

## • LEE MILLER •
## ROMANIA

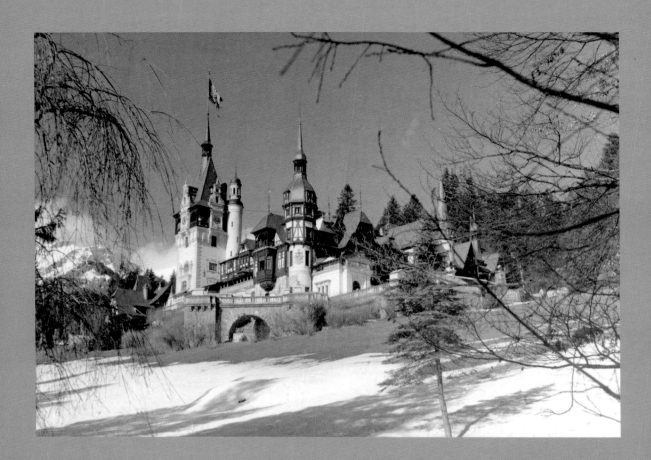

In 1938, Lee Miller decided to make a trip to the Baltic countries. She was 31 years old, married to Aziz Eloui Bey, an Egyptian businessman, and lived in Cairo. Before that, she had lived in New York, among artists, and in Paris, with Man Ray. She had started to make a name for herself as a photographer and, since her visit to Egypt, had become fascinated by landscapes and journeys. In Paris, she met Roland Penrose, an English painter, poet, writer, and friend of Picasso, Miró, and Tapies. She went to Romania with him. Putting her Packard "Arabella" on a boat that sailed for Alexandria, she waited for Penrose in Athens. After the Egyptian desert, London, France, and New York, here she was, first in Greece, then in Bulgaria, and finally in Romania—an uncommon journey at the time. Miller and Penrose went from town to town, sometimes driving all night, sleeping whenever they could. They visited the region of Bucharest, the Carpathians, and Transylvania. They went to medieval Sibiu, to the mythical Bran—where "Dracula's castle" is situated—and to Sinaia, "the pearl of the Carpathians." Lee Miller took photos of everything: tiny isolated villages, traditional wooden houses, gypsies they met on the road, dancers in their typical costumes, tsigane musicians, trees, and tobacco leaves drying on the walls of the houses. Roland Penrose also took one photo after another: buildings in Bucharest, children, Lee Miller with gypsies. Fleeting moments here, there, and everywhere. Moments that inspired him to produce *The Road Is Wider Than Long*, which is more a travel album than a book. It is a touching collection of reminiscences, photos, and secrets of a world the two artists discovered together—and an invaluable story about the beginning of a love affair. The next year, Lee went off to live with Penrose in England, but they did not

Lee Miller's souvenirs and photos, from the Carpathians to Transylvania.

marry until 1947. In the meantime, she was a photographer for *Vogue,* and a wartime correspondent; she tried out Hitler's bathtub, witnessed the Paris liberation, the concentration camps, and children dying in Vienna hospitals. She went all over the world with Penrose, was passionate about cooking in their house, Farley Farm, near London. She left some 60,000 negatives, manuscripts, letters, and souvenirs

that could fill several lives. They have been collated at Farley Farm by the Lee Miller Archives, a company managed by her son, Antony Penrose. The house is open to the public by appointment. The place has not changed much. The trip there is also extraordinary. Peter Kelih, an Austrian photographer, traveled all over Romania in the summer 2002. "The light, the atmosphere, the people, everything fascinated me,"

he said. He visited the Kalnoky Estate, in Miclosoara, owned by Count Tibor Kalnoky, a descendant of one of the oldest families in Transylvania. Once again the journey is out of the ordinary. It relates to the history of a family who returned to their home after fifty years in exile. The Kalnokys receive guests in housaes adjoining their castle, in the heart of a tiny lost village, at the foot of the Carpathians. The village fortress was first documented in 1211, but was destroyed. The Kalnoky castle was started in the sixteenth century. The renovated houses commemorate a fairy-tale Romania, and features personal objects, books everywhere, a whole load of souvenirs, and astonishing old bathrooms. An authenticity re-created by those enamored of their country. "We did not seek perfection," they say. It is why the place is so captivating. The Count Kalnoky Estate provides all sorts of suggestions for strolls: Sighisoara, Ghelinta (both UNESCO World Heritage conservation areas), Bran and its neighboring villages, churches, manor houses, and castles, among others. You must go there very soon for the adventure rent a car—why not a Packard—and take Roland Penrose's book with you.

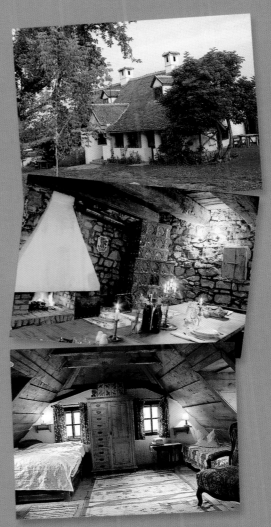

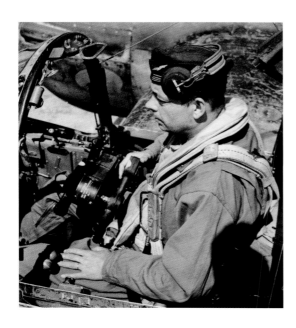

Antoine de Saint-Exupéry fell in love with the desert on his first trip there. In 1926, Saint-Exupéry was hired by the Latecoere Compagnie, which, well before French airmail service and Air France, flew between Toulouse, France, and Dakar, Senegal. He had dreamed of it, and at last, there he was, in the midst of this much admired atmosphere, rubbing shoulders with the old hands in the restaurant; they never said much, exhausted by the effort. Apparently, if one of the them came back from Alicante or Casablanca, with drenched leather jackets, Saint-Exupéry would timidly question the man about his journey and use his brief answers to build up a fabulous world. Indeed, Saint-Exupéry used the stories to conjure traps, snares, cliffs suddenly rising up, and disturbances that could uproot oaks. This was his ideal, his obsession, his life.

Aircrafts' crates provided no security whatsoever at the time. The engines were likely to let you down without any warning. Information supplied by the radio was often approximate. But this was the existence that St.-Ex. wanted: mixing risk, difficulty, the unknown, freedom, and death, that silent companion. He was soon posted as airfield manager at the tiny outpost of Cape Juby in Morocco, where he went to fetch pilots who had broken in the desert. There he met Guillaumet and Mermoz, with whom he "knocked around a lot," and with whom he opened the Patagonia—Punta Arenas line. The former disappeared at the controls of his *Southern Cross*, above the Atlantic. The latter died in his aircraft when it caught fire. In 1935, Saint-Exupéry himself nearly died. A trek was organized between Paris and Saigon in an attempt to reach both capitals in less than five days and four hours. Just like a kid at play, Saint-Exupéry wanted to beat the others and get his hands on the 150,000 francs prize. He left Casablanca with Prévot, his mechanic. Four hours later, at 2:45 a.m., his *Simoun* disappeared in the Libyan Desert. The two friends woke up in the middle of a blond stretch of desert, "where the wind had marked its swell just as on

# IN THE SAHARA A THOUSAND-YEAR-OLD OASIS

## · ANTOINE DE SAINT-EXUPÉRY · THE SAHARA

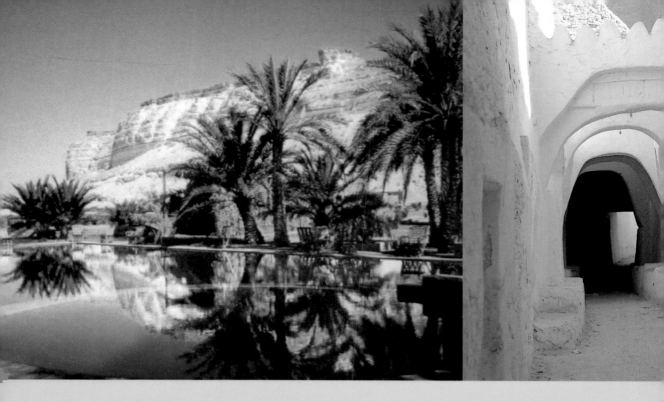

the sea," and as soon as they had recovered from their surprise, they started to walk in the sun, scraping the sand with their feet to leave tracks. But they soon forgot to leave tracks. Having left their only liquid in the aircraft, they miraculously managed to reach what was left of *Simoun*; they licked their flasks and tried to concentrate on the emergency at hand. Water, reference points, laying traps for food. Thoughts started spinning. On what do foxes and desert plants feed in the desert? How do you recognize a mirage? How do you control fear? They wandered around for three days before finally meeting a Bedouin caravan.

Saint-Exupéry's book *Le Petit Prince* is the same story: an aviator in the desert, thirst, sand, rocks, sun, a fox, and a flower who saw a caravan go by one day. Then an oasis, a sort of hotel with no address, somewhere in the middle of the sand…

This is Adrere Amellal, the White Mountain. It is a traditional village of earth and stone, situated in the incomparable Siwa Oasis. Alleyways, staircases, vaulted

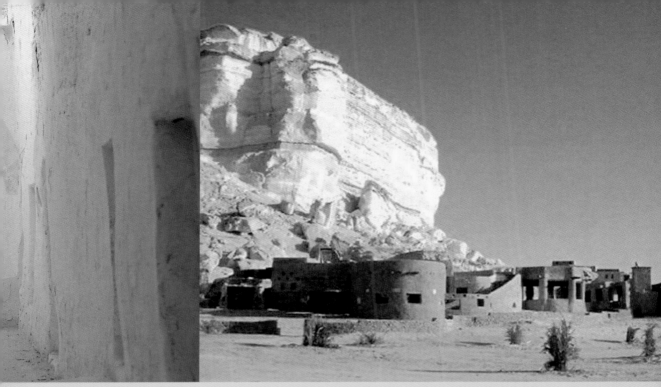

rooms, no electricity, no air-conditioning (but an ingenious ventilation system that had been adopted a long time ago by the inhabitants). An absolute art of living, totally natural, elegant beyond elegance, in the heart of the burning winds. There you live the life of the desert: cool at night, hot in the day, with candles and oil lamps that light up by magic in the evening in the sheltered rooms set in the shade and discreet to the extreme. It is as near as possible to what the oasis was like more than two thousand years ago, at the time of the caravans. An eco-lodge, you might call it. In fact, it is a wonderful reward for those who have crossed sand and dunes to get to Siwa, a legendary mirage on the Libyan frontier that was once visited by Alexander the Great.

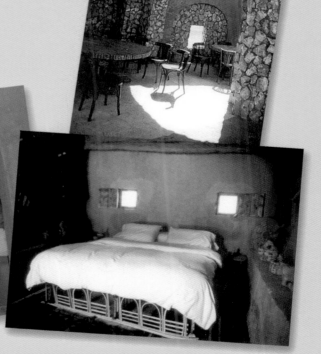

# AND ALSO...

Canada: Atnarko Retreat Bed & Breakfast: www.atnarko.ca

Cornwall: Fowey Hall: www.luxuryfamilyhotels.com

Spain: La Torre del Visco: www.torredelvisco.com

Grand Canyon: El Tovar: www.grandcanyonlodges.com

Borneo Islands Borneo Eco Tours: www.borneoecotours.com

Isle of Skye: Three Chimneys: www.threechimneys.com

Montana: Triple Creek Ranch: www.triplecreekranch.com

Morocco: Best of Morocco: onfo@realmorocco.com, tel. 00 44 1380 8285 33

Namibia: Epacha Game Lodge and Spa: www.epacha.com

Utah: Valley of Gods Bed & Breakfast, Mexican Hat: www.valleyofthegods.cjb.net

Adventure Collection: www.adventurecollection.com

For walking amateurs: Country Walkers : www.countrywalkers.com

For desert amateurs: www.deserts.fr

Adventures all over the world by 4-wheel drive with Étienne Smulevici: www.essorr.com

Travel with the National Geographic France magazine: www.nationalgeographic.fr

# BIBLIOGRAPHY

Frison-Roche, Roger, *Premier de cordée*, Paris, Arthaud, 1999.

Gellhorn, Martha, *Travels with Myself and Another*, New York, Jeremy P. Tarcher, 2001.

Geniesse, Jane Fletcher, *Passionate Nomad, The Life of Freya Stark*, New York, Random House, 1999.

Greene, Graham, *The Power and the Glory*, London, Penguin, 2003.

Maugham, Somerset, *The Gentleman in the Parlor*, New York, Kessinger Publishing Company, 2004.

Moorehead, Caroline, *Martha Gellhorn: A Life*, London, Chatto & Windus, 2003.

Stark, Freya, *Alexander's Path from Caria to Cilicia*, London, J. Murray, 1958.

Stevenson, Robert Louis, *Travels With a Donkey in the Cévennes*, Köln, Konemann, 1998.

# PHOTO CREDITS

# ACKNOWLEDGMENTS

The author would above all like to thank her husband Bertrand, who never tires of visiting airports and tasting all the beers in the world, her publisher Martine Assouline and her increasingly impressive team, her parents Philippa and Eduardo Yrarrazaval for their youthful spirit, their ideas and unique memories, her sister Alejandra di Andia and her daughter Joy, valued helpers and photographers of merit, Janie Samet, tremendous journalist and friend, her translator and friend Diana Stewart. She would also like to express her thanks to Arabella Hayes and Roland Penrose (Lee Miller Archives), Jean-Paul Gondonneau (Manager of Turavion in Chile), Tony Fox (Oxford), Aguas Grandes Tourism (Argentina) who rescued her with great skill from a difficult situation, Glenn Bartels-Harley Davidson (Los Angeles), Éric Tirelli (Voyageurs du Monde), Éric Laniesse (Manager of Actuel Voyages in Paris) and his brilliant team who for over ten years have retrieved irretrievable situations from Baja to Iguazù, Jason Borger (Montana), Claudio Alonso (Brazil) "muito obrigado!", Dominique de Souza and Éliane de la Béraudière for their superb photography of Angkor, Tom Sutherland (London Travellers Club), the Chamonix Tourist Information Center and Catherine Cuenot, talented iconographer, Peter Kelih for his photographs of the Kalnoky Estate, Hélène Vasseur (*National Geographic* France), Giulia Marsan (Volcanoes Safaris), Maryse Masse (Relais & Châteaux), Christian Panhard who opened his magnificent Le Mans albums for her...as well as all the hotel managers, those in charge of websites, public relations, cow-boys, bikers, flyfishing adepts, barmen and unexpected friends met by chance along the way, and with whom she shared a year of uninterrupted email correspondence.
Gracias a todos.

The publisher would like to thank the photographer Aline Coquelle and Corbis for their collaboration, as well as AKG Images, Cécile Bouvet, Jean Noël Delamarre, Kobal, Christophe L. Collection and Rue des Archives for their help in achieving this book.